IMAGES
of America

VINTAGE BIRMINGHAM SIGNS

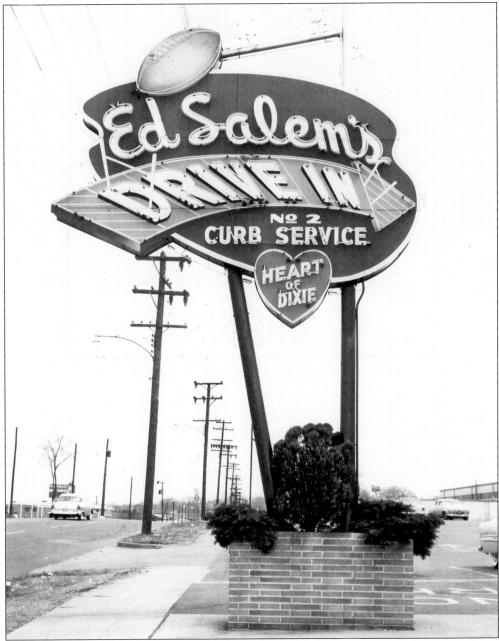

Former University of Alabama football star Ed Salem capitalized on his reputation with a chain of drive-in restaurants. His first location was near the Norwood neighborhood, and this one, his second, was on Third Avenue South. In the distance, notice the sign for the Putt-Putt Golf course peeking above the passing automobile. (Ace Neon collection.)

ON THE COVER: Nothing that had come before could possibly have prepared Birmingham for the wonders that awaited it when Eastwood Mall opened on August 25, 1960. The city had never seen anything like it, as it was the first all-enclosed shopping mall in the South. (Birmingham Rewound collection.)

IMAGES
of America

VINTAGE BIRMINGHAM SIGNS

Tim Hollis

ARCADIA
PUBLISHING

Published by Arcadia Publishing
Charleston SC, Chicago IL, Portsmouth NH, San Francisco CA

Printed in the United States of America

Library of Congress Catalog Card Number: 2007940249

For all general information contact Arcadia Publishing at:
Telephone 843-853-2070
Fax 843-853-0044
E-mail sales@arcadiapublishing.com
For customer service and orders:
Toll-Free 1-888-313-2665

Visit us on the Internet at www.arcadiapublishing.com

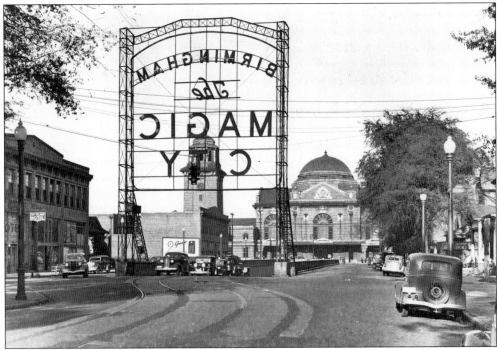

No, the photograph isn't printed backward. This huge electric sign was erected in 1926 to welcome travelers arriving in Birmingham via the magnificent railroad terminal station; thus its front faced the station and everyone else had to look at the back of the sign. (Birmingham Public Library [BPL] collection.)

CONTENTS

ACKNOWLEDGMENTS

As will be obvious from the photograph credits throughout this book, none of this would have been possible without the help of the families of those who ran Birmingham's three largest neon sign companies: Ernest Langner of Dixie Neon, Virginia Fesperman of Alabama Neon, and Delene Sholes of Ace Neon. Other memorabilia collectors who contributed their materials to help fill in gaps are credited as their photographs appear. Mention should also be made of the Web site www.BirminghamRewound.com, to which many images have been donated over the past few years. To paraphrase the famous Bargain Town U.S.A. jingle, "If you like this book, you'll LOVE Birmingham Rewound." Take it from us, "You'll go back, back, back for more, more, more."

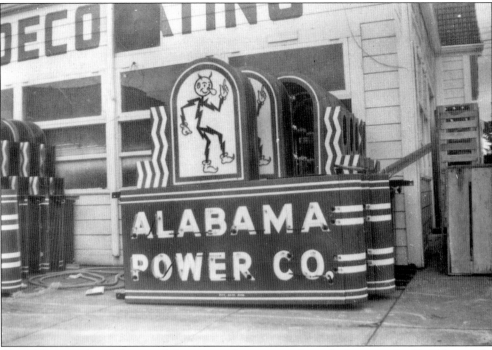

Dixie Neon produced dozens of these signs featuring trademark character Reddy Kilowatt for local Alabama Power offices across the state. Amazingly, a few of them can still be found along small-town Main Streets today. (Dixie Neon collection.)

INTRODUCTION

Have you ever stopped to think about how many of your nostalgic memories involve signs? Probably not, unless you live in the past as I do. (That is not in a figurative sense, either; my house is a museum of pop culture history, so I really do live in the past.) Regardless, the following pages will prove that signs, as well as the larger commercial landscape, have played a bigger part in Birmingham residents' past than one might expect.

For the purposes of this book, the term "signs" includes not only the classic neon signs that are usually associated with the name, but also billboards, signs painted on brick walls, and even more modern plastic signage (which has been around for so long that even its early examples look nostalgic by now). Because Birmingham's neon sign companies did a far more complete job of archiving photographs of their work than did the others, the neon variety will far outnumber the rest—but in many cases, as you will see, a single photograph will involve more than one type. You should plan on having your magnifying glass handy in order to fully experience all the background detail in some of these priceless shots.

Unfortunately, there are still some well-remembered Birmingham signs that do not appear here simply because no one seems to have preserved any photographs of them. One of the most often mentioned is the spectacular one atop the old Merita bakery on Twentieth Street with its giant loaf of bread with neon slices falling off onto a plate. Exhaustive research has failed to turn up a single view of that landmark. Also missing in action are some of the giant fiberglass figures that served as signage for their respective companies: the Consolidated Dairies cows and the giant Lynn Strickland tire man (although at least he does still exist, but not in the same location). Perhaps some of these will turn up later, and when they do, you can certainly expect them to appear on www.BirminghamRewound.com.

Since signs are purely visual, that is enough wordy introduction. Let's get right into the photographs themselves and see whether you agree that these signs, originally meant only to sell a product or service, evoke fond memories for you. Even though most of them are now consigned to the junkyard, in photographs such as the ones that follow their lights can glow forever.

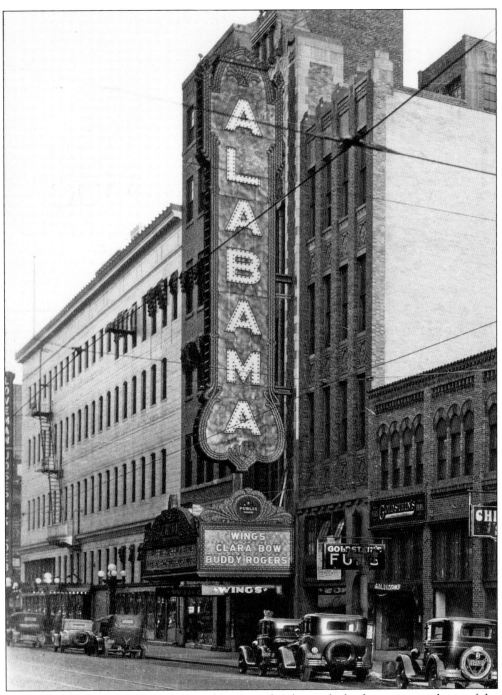

There is hardly anyone in Birmingham who is not familiar with the famous vertical sign of the Alabama Theatre. However, this photograph from 1928, the year after the showplace opened, is one of the few that shows the original screw-in lightbulbs that outlined the letters. Later the bulbs would be replaced with red and green neon, which continues to light the Third Avenue North sidewalk today. (BPL collection.)

One

THE LIGHTS ARE MUCH BRIGHTER THERE

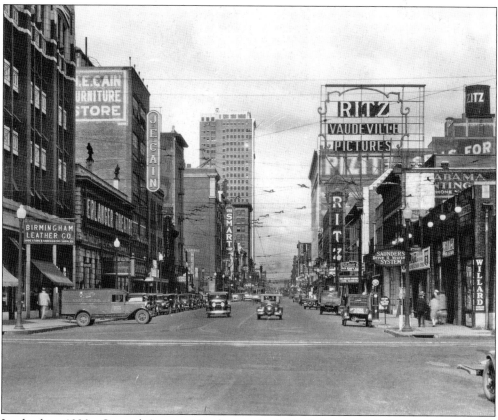

In the late 1920s, Second Avenue North was the hub of theater and shopping activity. In this incredible shot, notice the Erlanger Theatre (formerly the Jefferson) and the J. E. Cain furniture store on the left and the newly opened Ritz Theatre and huge Pizitz store on the right. (BPL collection.)

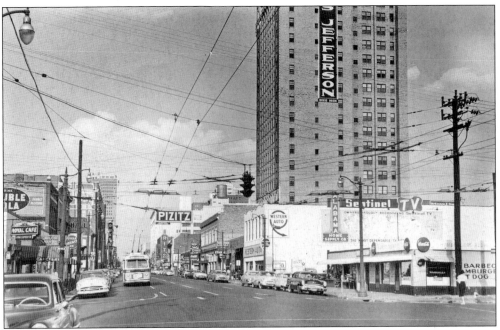

This September 1954 view of Second Avenue North was taken from a couple of blocks west of the photograph we just saw. By that time, other types of stores and restaurants had moved into the neighborhood, but the Ritz and Pizitz would hold down their respective lots until the 1980s. (Dixie Neon collection.)

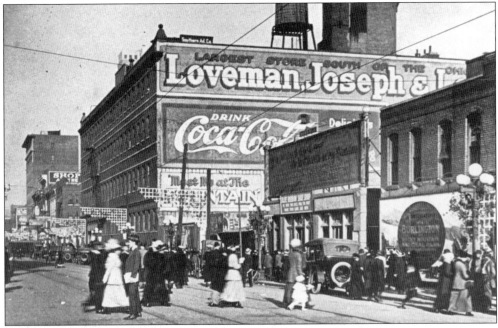

The Loveman, Joseph, and Loeb department store was no shy violet when it came to announcing its presence on Third Avenue North. If you do not remember this gigantic mural, it is probably because the wall was covered by the construction of the Alabama Theatre next door in 1927. (Birmingham Rewound collection.)

By 1954, Loveman, Joseph, and Loeb had simplified its name to Loveman's, and Dixie Neon installed two of these elegant signs with backlit letters, one on Third Avenue and the other on Nineteenth Street. Notice the crisscrossing escalators visible through the show window. (Dixie Neon collection.)

After Loveman's closed forever in April 1980, the building sat abandoned until being renovated as the McWane Science Center. In the mid-1980s, this fading mural remained visible on the "skywalk" that connected the parking deck with the then-vacant store building. (Birmingham Rewound collection.)

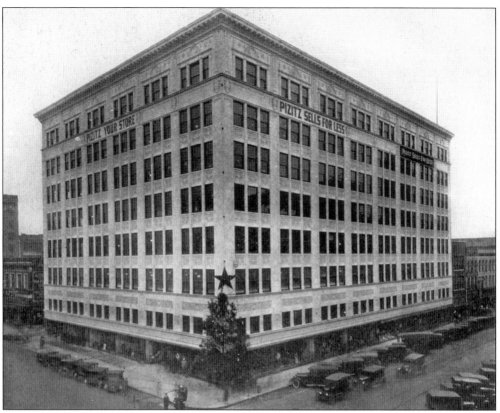

After operating out of several smaller buildings, Louis Pizitz had this imposing, seven-story monolith built as his flagship store. It opened in time for Christmas 1925, when this photograph was taken. Signage was noticeably minimal because the building itself was a pretty effective way of advertising the store's presence. (Birmingham Rewound collection.)

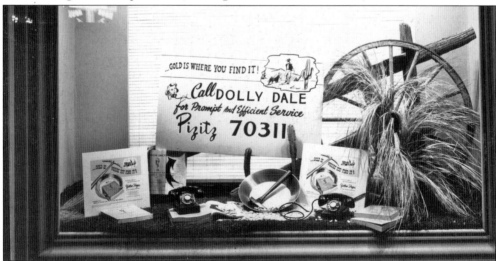

This is one of Pizitz's many store display windows, probably from the late 1940s or early 1950s. Who was "Dolly Dale"? No one, actually, but Pizitz used that name for its call-in order service for many years. (Birmingham Rewound collection.)

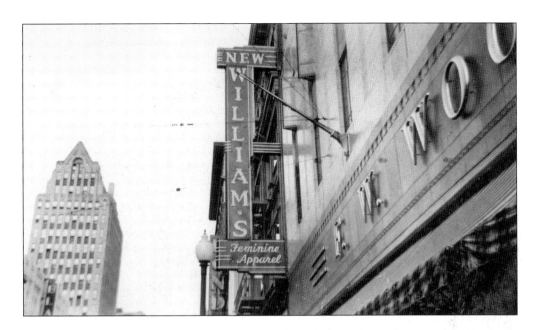

Not all downtown stores were as huge and visible as Loveman's and Pizitz. New Williams was a Third Avenue fixture for fine women's clothing; in these two unusual shots, we also get a close-up view of next-door neighbor Woolworth's traditional gold letters (pictured above) and a New Williams billboard atop the Carr Floral store on Twentieth Street (pictured below). (Above, Dixie Neon collection; below, Alabama Neon collection.)

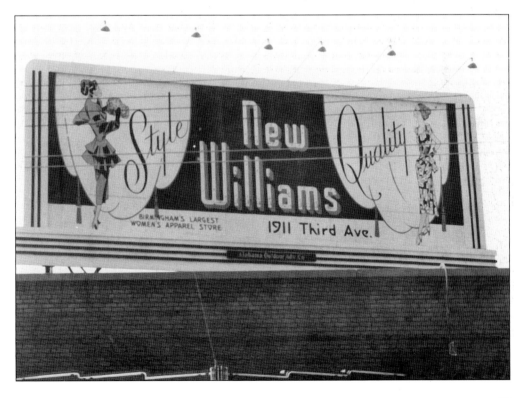

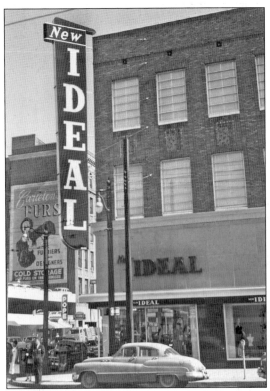

We cannot forget the New Ideal store at Second Avenue and Eighteenth Street, but from this angle, also notice the giant, brick wall sign for Carleton Furs across the street. That masterpiece would have been obscured when Loveman's built its parking deck on the corner in 1971. (Dixie Neon collection.)

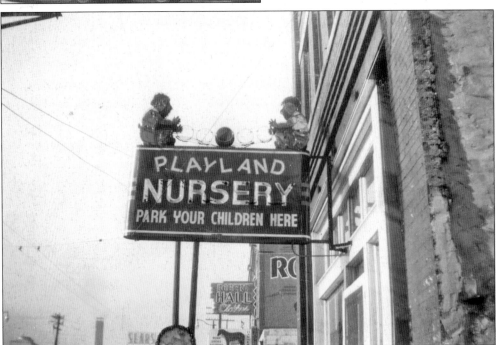

This sign definitely dates from a different era in the concept of child care. The neon tots could roll their neon ball back and forth forever while parents "parked their children" and headed off to Sears, whose Second Avenue sign is visible at the very bottom of the image. (Dixie Neon collection.)

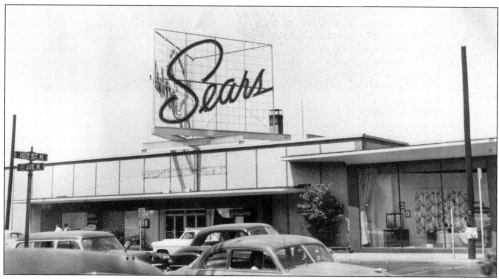

While the smaller sign on Second Avenue had been there since the Sears building was built in 1941, in July 1955, a larger and more eye-catching, green neon spectacular was installed on the First Avenue side of the sprawling department store. (Dixie Neon collection.)

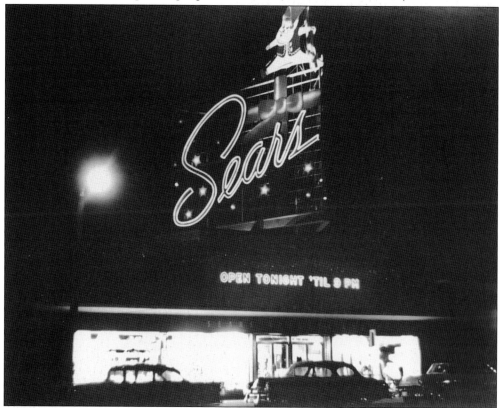

It is too bad this image can't be viewed in color because seeing how Sears dressed up its already magnificent sign for the Christmas season is enough to make any former Birmingham kid weep out of sheer nostalgia. (Polly Chambers collection.)

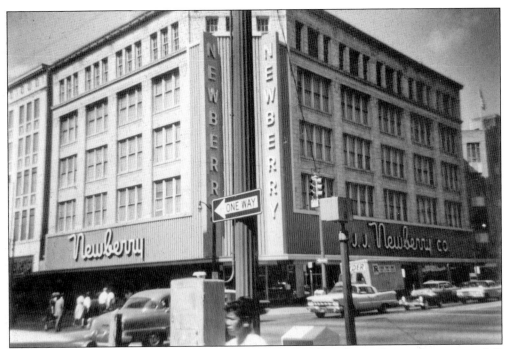

Downtown was loaded with 5-and-10¢ stores, as well as the classic department stores. J. J. Newberry occupied a corner of Second Avenue and Nineteenth Street from 1936 until 1995 when the building was demolished to make way for the McWane Science Center's IMAX Theater. (BPL collection.)

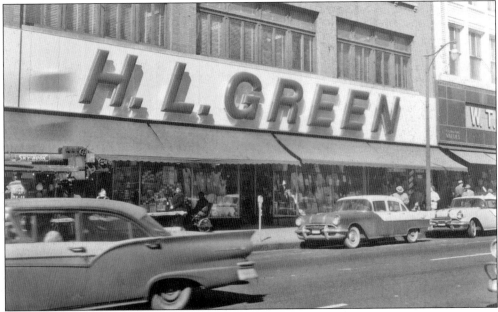

Another 5-and-10¢ fixture was H. L. Green, located in what older residents remembered as Silver's. Inasmuch as a Family Dollar store operates in the space today, one might observe that the former Silver's/Green's comes closest to having maintained its original function all these years. (Dixie Neon collection.)

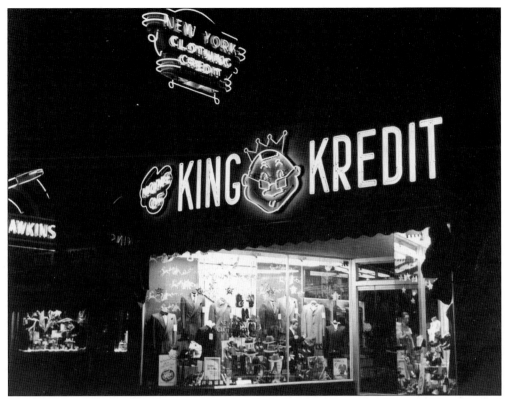

The Sher family first called their store the New York Clothing Company, "home of King Kredit," but over the years, King Kredit became the official name of the business. It later evolved into Mr. King Furniture. The grinning, bucktoothed monarch was the logo in all of the business's incarnations. (Ace Neon collection.)

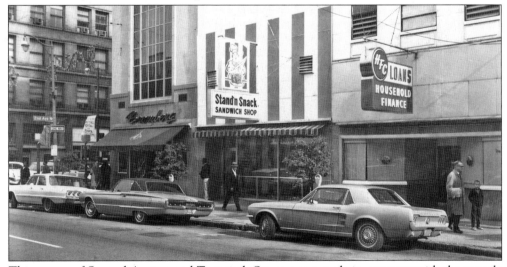

This corner of Second Avenue and Twentieth Street was a study in contrasts with the upscale Bromberg's rubbing jeweled shoulders with Stand 'n' Snack and heavy radio advertiser Household Finance Corporation. Remember their jingle? "Borrow confidently at H-F-C!" (Birmingham Rewound collection.)

During World War II, Alabama Neon did its part for the cause by installing this red-white-and-blue message on the front of the Burger-Phillips building. After the war, it was repainted and rewired to become Burger-Phillips's own vertical marquee. (Alabama Neon collection.)

Alabama Neon teamed with Alabama Outdoor Advertising to create this incredible hybrid of billboard, neon sign, and giant thermometer, all in the service of Burger-Phillips. (Alabama Neon collection.)

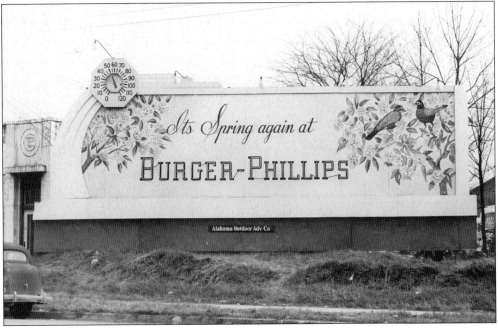

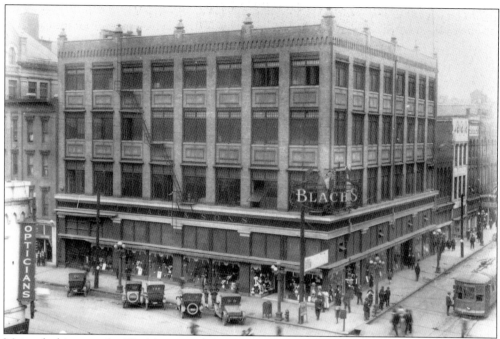

Major clothing retailer Blach's manned the corner of Third Avenue and Nineteenth Street until the mid-1930s when it moved to the Twentieth Street end of the block to make way for the new S. H. Kress store on this spot. (Don Sharpe collection.)

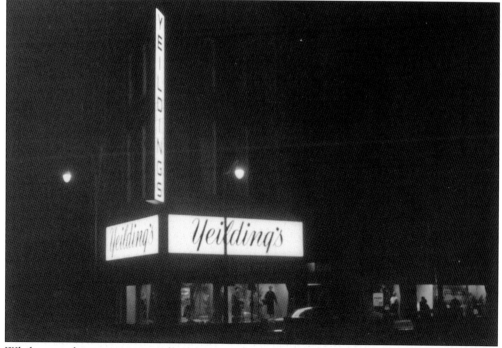

While some businesses went all out to attract attention with flashing, multicolored signage, Yeilding's went in the opposite direction, lighting up the night with simple black lettering against a stark-white background. (Dixie Neon collection.)

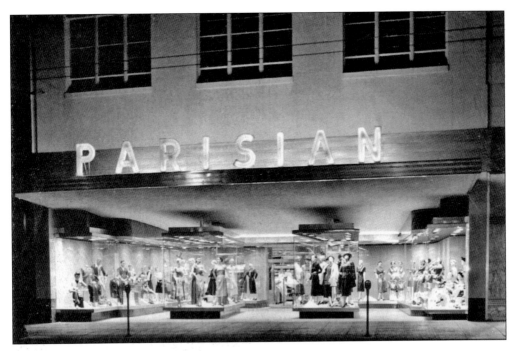

Parisian (above) was one of the most respected names in Birmingham retail for almost 120 years. While its flagship store sat on the north side of Second Avenue with its brilliantly lighted blue letters, the Belk-Hudson store (below) squatted on the south side about a block away, greedily watching its rival with the elegant French name. After a long absence, Belk returned to Birmingham in 2007 and swallowed Parisian alive, leaving no trace of its victim's century-long reign. (Above, Birmingham Rewound collection; below, Dixie Neon collection.)

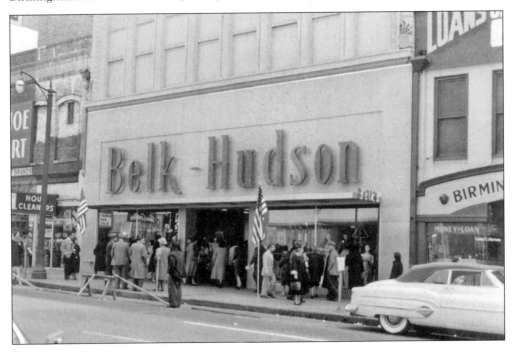

Owner Izz Eubank thought nothing of plastering his visage on the front of his Sample Shoes store on Second Avenue North. Next door is the first location in what would become the chain of Bargain Town U.S.A. discount stores. (Dixie Neon collection.)

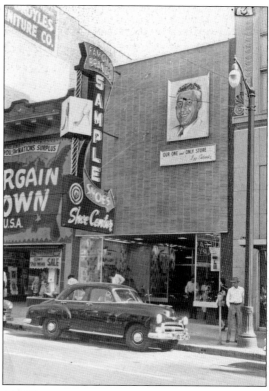

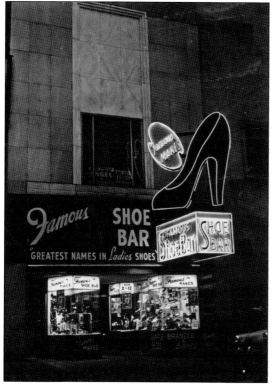

In the same block where Izz Eubank grinned down at passersby, the Famous Shoe Bar tried to grind him into the pavement with its giant, rotating, high-heeled pump. The two store owners were reportedly as bitter as two rivals could possibly be. (Dixie Neon collection.)

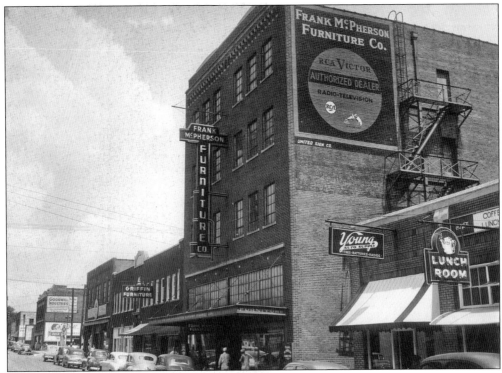

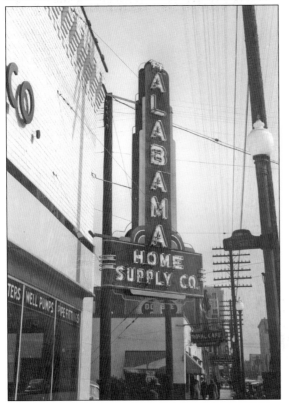

In Ensley, the Frank McPherson Furniture Company advertised both radio and television on its brick wall sign. That indicates the sign could not have been painted until after 1949 when television first arrived in Birmingham. At least it is unlikely that a store would have been selling television sets when there was no programming to watch. (Alabama Neon collection.)

Alabama Home Supply was not deliberately trying to ape the Alabama Theatre's sign, even though the two did appear to be neon kissing cousins. The home supply store was so proud of its miniature vertical version that it was prominently featured as the store's logo in all its newspaper advertisements. (Dixie Neon collection.)

Second Avenue North was an impressive sight at night with the Broyles Furniture and Belk-Hudson signs piercing the darkness and, in the distance, the rooftop sign and beacon of the Thomas Jefferson Hotel towering above all. (BPL collection.)

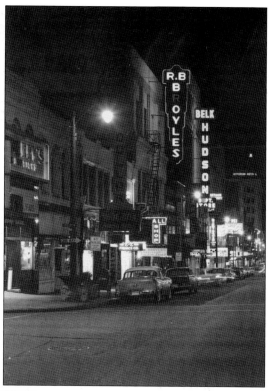

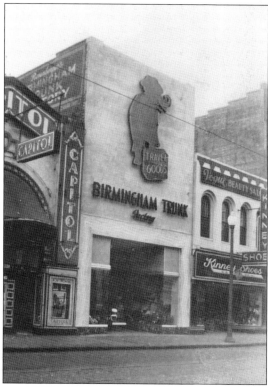

Rosenberger's Birmingham Trunk used the emblem of a red elephant standing on a suitcase. As seen here, the earlier sign was positioned flat against the building, while a later version projected over the sidewalk. (Dixie Neon collection.)

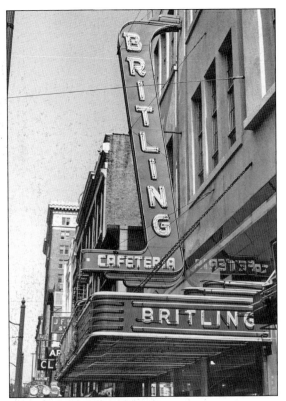

There were Britling Cafeteria locations throughout Birmingham, but this particular one was on Twentieth Street. At various times, others could be found on First Avenue North, Third Avenue North, and Highland Avenue at Five Points West and Western Hills Mall, and in Hoover, Roebuck, and the First National/Southern Natural building. (Alabama Neon collection.)

In 1951, Morrison's Cafeteria moved into what had formerly been the Royal Theatre, Birmingham's home for Western films. Diners might not have realized they were grazing where the deer and the antelope once played. (Dixie Neon collection.)

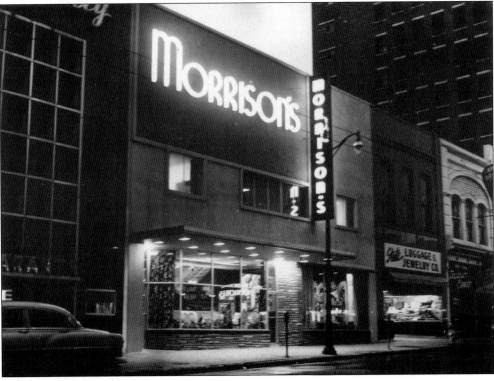

On Eighteenth Street, Dixie Cream Donuts tempted folks to stop by en route to the Alabama Theatre. Not to be outdone, the theater operated its own popcorn concession nearby (visible in the background). (Dixie Neon collection.)

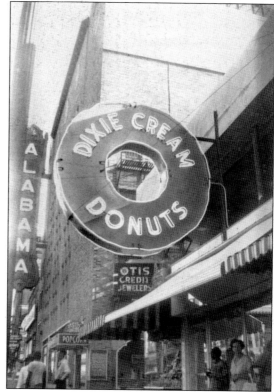

The Ward Baking Company turned out Tip-Top bread on First Avenue, across the street from Sears. The bakery would eventually become Cousin Cliff's first television sponsor in 1954. (Alabama Neon collection.)

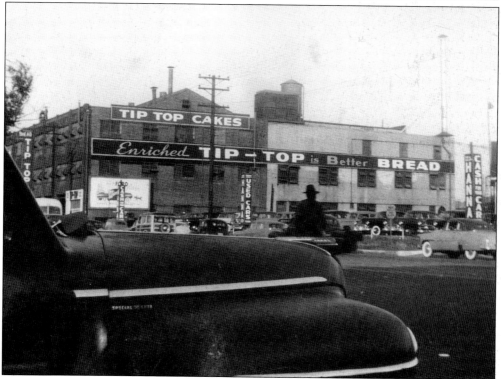

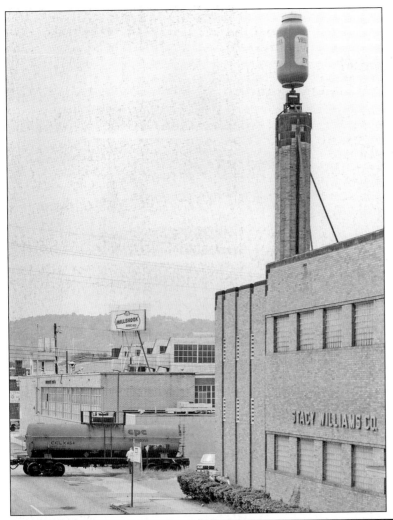

Millbrook bread was famed for using the "Peanuts" characters in its advertising. Notice the faded Charlie Brown on the abandoned delivery truck in the photograph below. The bakery on Thirteenth Street had a replica of Snoopy's doghouse on the roof. Also, don't forget the giant jar of Yellow Label syrup atop that company's headquarters (left). (Warren Reed collection.)

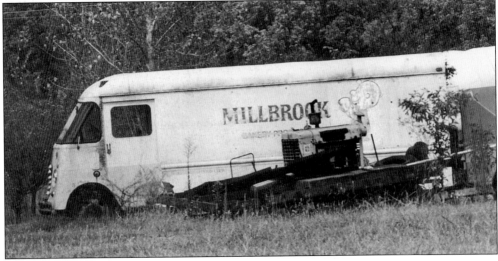

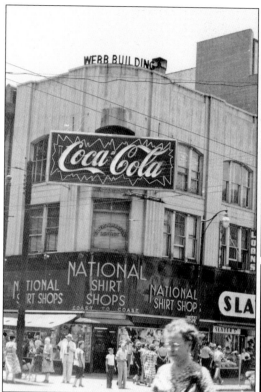
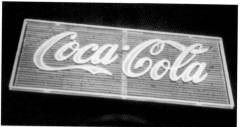
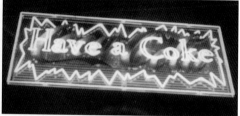
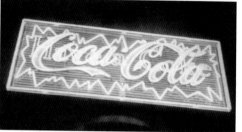

At Second Avenue North and Twentieth Street, Dixie Neon installed an elaborate Coca-Cola sign that is documented for posterity in both this daytime shot (above left) and the three different phases of the nighttime version (above right). However, Coca-Cola did not put all its bottles into one rack downtown; this billboard clock (pictured below) could be found at Fourth Avenue North and Nineteenth Street. (Dixie Neon collection.)

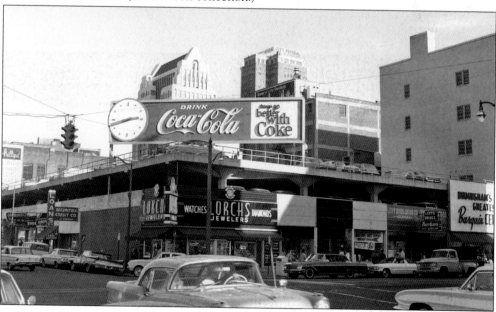

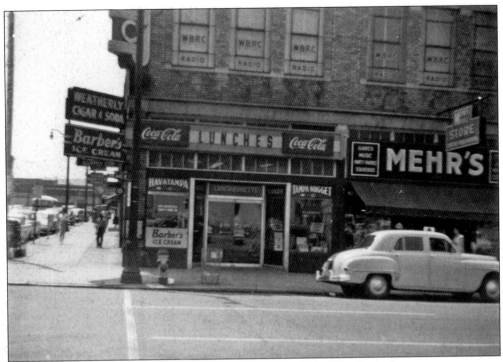

The Weatherly drugstore was on the corner of Second Avenue North and Eighteenth Street. As you can see here, the second floor was occupied by the studios of WBRC radio; the drugstore location eventually became a Pasquale's Pizza before the entire block was razed in 1982. (Dixie Neon collection.)

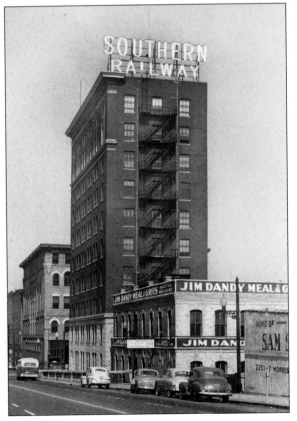

The Twenty-Second Street viaduct was a jim-dandy place to see both the Southern Railway sign and a brick wall sign advertising Jim Dandy meal and grits. (Alabama Neon collection.)

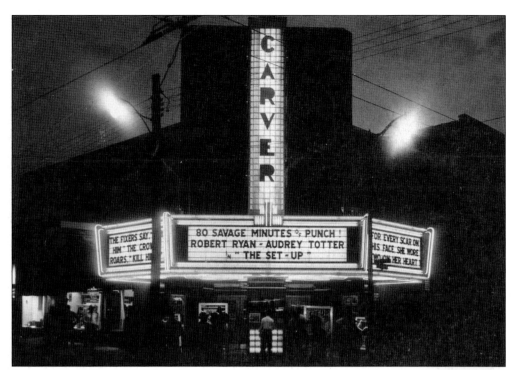

Since the ugly facts of the day meant that not everyone was welcome at the downtown theaters, the African American community responded with the lavish Carver Theatre on Fourth Avenue North. (Alabama Neon collection.)

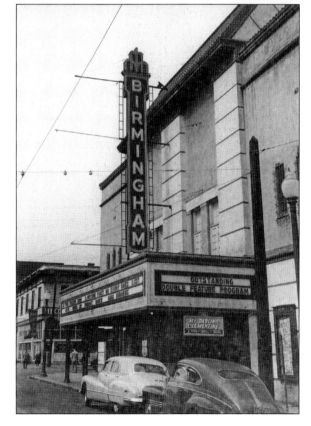

The Birmingham Theatre was formerly known as the Pantages vaudeville house. This photograph was made in 1946; the theater would be torn down to make way for a parking lot in 1950. (Alabama Neon collection.)

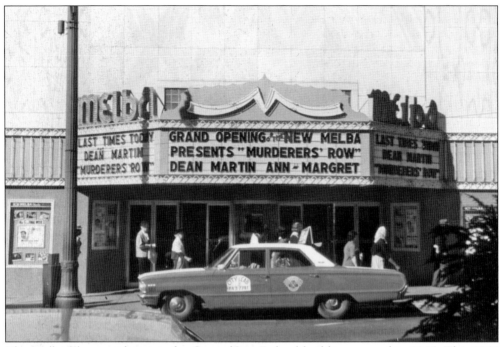

The Melba Theatre adjoining the Comer/City Federal building opened in 1946. This 1966 marquee is advertising the latest in a long string of remodelings applied to the movie house. (Dixie Neon collection.)

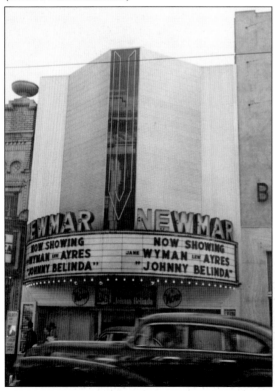

Look back at page 23 and compare it with this image to see how the Newmar Theatre evolved from the much-earlier Capitol Theatre. This is how the Newmar appeared in 1948. (Dixie Neon collection.)

The Steiner Bank building, constructed in 1890, ranks as one of the oldest downtown structures still standing. Across the street, notice the rooftop sign for Birmingham Light and Power, which supplied the city's electricity and operated the streetcar system. (Dixie Neon collection.)

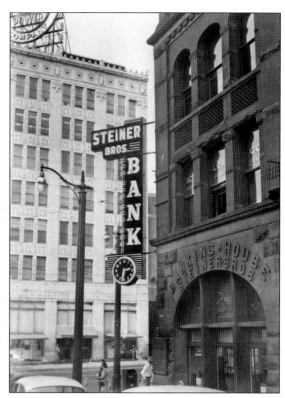

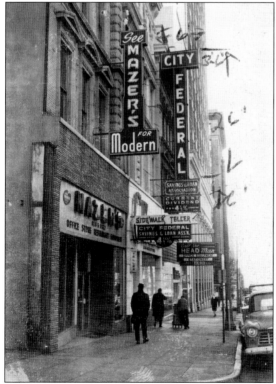

This shot of the City Federal location on First Avenue North includes Dixie Neon owner Ernest Langner's handwritten notations as to the size of the vertical sign. (Dixie Neon collection.)

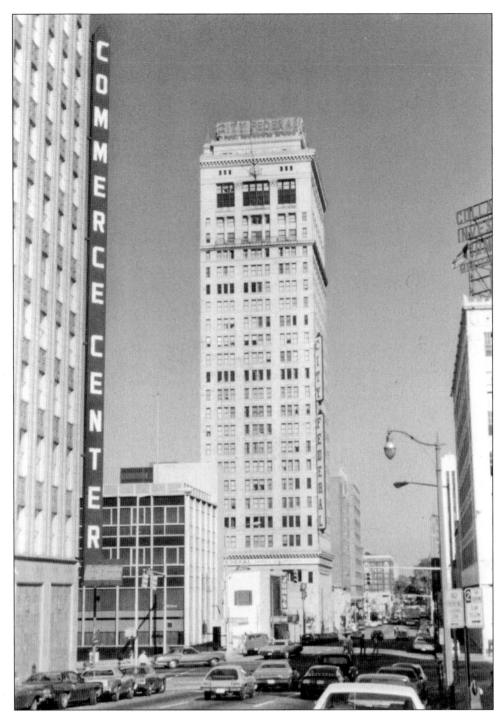

In 1964, Dixie Neon's crews had to work at dizzying heights above Second Avenue North and Twenty-First Street to install City Federal's new vertical sign on the corner and a flashing rooftop sign that could be seen for miles. By the time of this photograph, the former Protective Life building in the foreground had become the Birmingham Chamber of Commerce offices, with another giant Dixie Neon creation on its corner. (Dixie Neon collection.)

Originally, the City Federal sign consisted of red neon lettering against a background of white vertical neon (pictured below), but wind and weather at that altitude soon made short work of the white tubes, leaving only the lettering to glow alone. (Dixie Neon collection.)

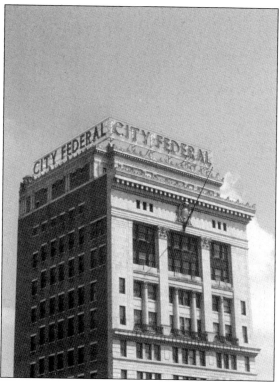

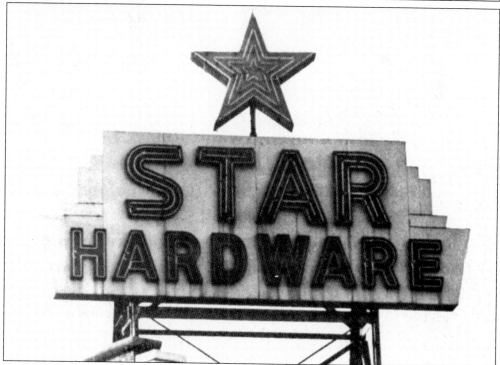

Across the corner from Sears, Star Hardware's pulsating blue star was an unmistakable nighttime sight. (Martin Schulman collection.)

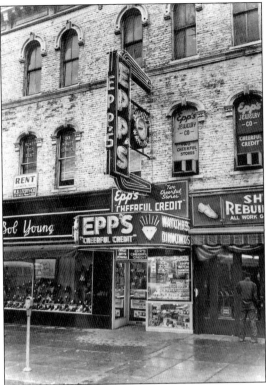

The Epp's jewelry store on Nineteenth Street certainly occupied a narrow space, but it made the most of its available sidewalk frontage with this colorful sign and marquee. (Birmingham Rewound collection.)

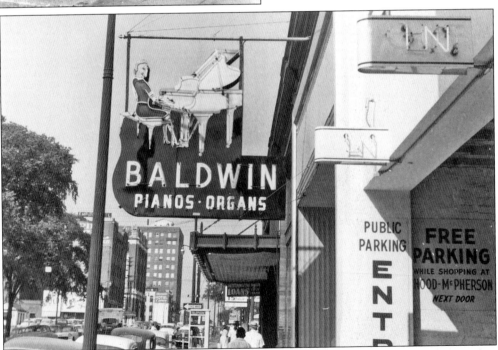

Have you heard of the "Unfinished Symphony"? This neon lady was no doubt playing that piece on her Baldwin piano while her nightly concerts went on and on without ending. (Dixie Neon collection.)

If these photographs have been enjoyable so far, Lollar's is partly to thank. Many of the images seen here were processed at one of the several Lollar's camera shops throughout Birmingham. (Alabama Neon collection.)

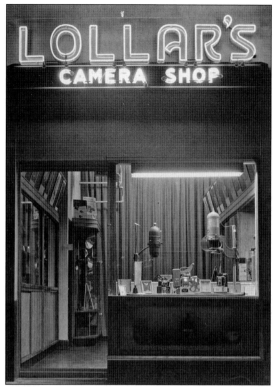

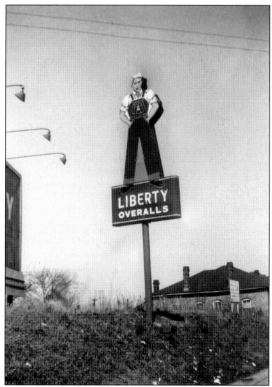

This stern-looking Liberty Overalls wearer stood on Third Avenue west of downtown for decades until the sign literally crumbled away from rust and exposure. (Dixie Neon collection.)

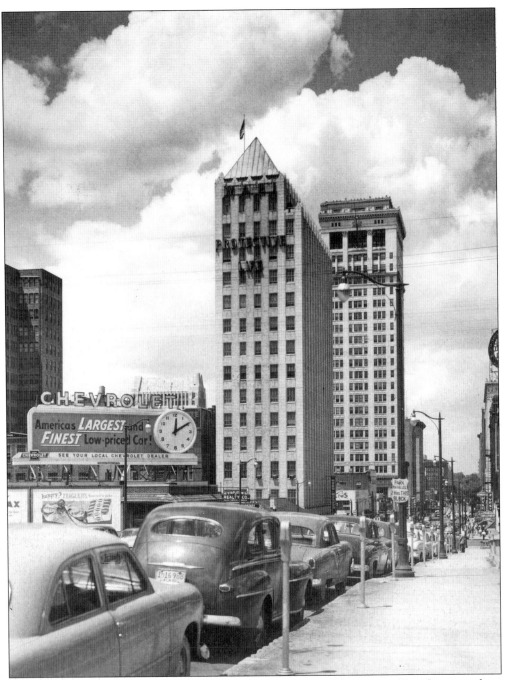

It is easy to get lost wandering around in this beautiful view of the Twenty-First Street viaduct. Of special note are the Chevrolet billboard and clock, and the Protective Life building, which at this time was still home to the radio studios of WAPI. (BPL collection.)

Two

FOOD FOR THOUGHT

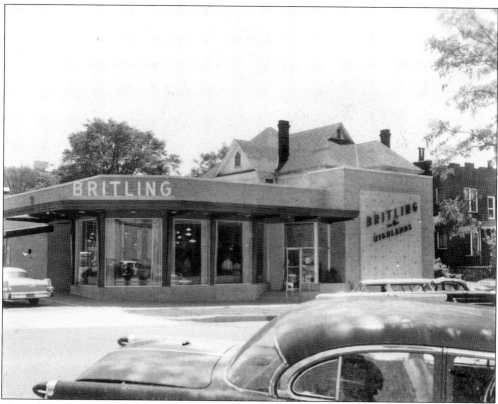

One of the downtown Britling Cafeterias was seen on page 24, but this view of the Britling location on Highland Avenue is a great way to lead into the chapter on area restaurant signage. (Dixie Neon collection.)

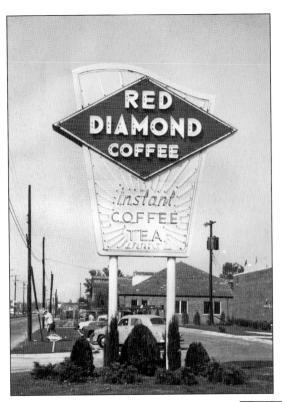

Red Diamond, the signature brand of the Donovan Coffee Company, established its headquarters on Vanderbilt Road far from the city center. Dating back to 1906, Red Diamond coffee and tea have been Birmingham traditions. (Dixie Neon collection.)

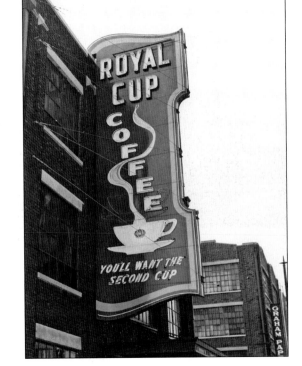

In contrast to Red Diamond, competitor Royal Cup coffee set up business downtown in 1896 where its tantalizing aroma permeated the surrounding neighborhood. (Alabama Neon collection.)

This sign for the Alma White Cafeteria is classic enough by itself, but it would be even more rewarding to use a magnifying glass to tour the main street of Woodlawn in the background. (Ace Neon collection.)

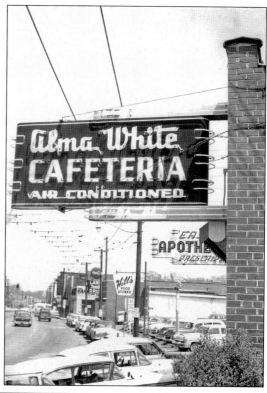

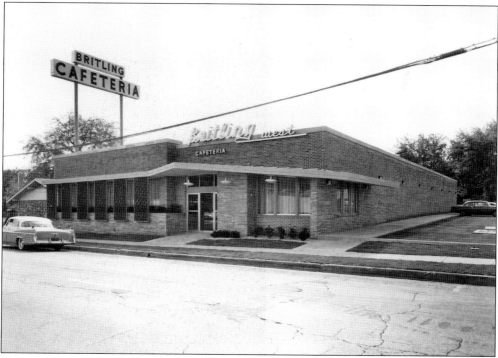

Here we are at another Britling location, this time at Five Points West. This building later served as the Five Points branch of the Birmingham Public Library. (Birmingham Rewound collection.)

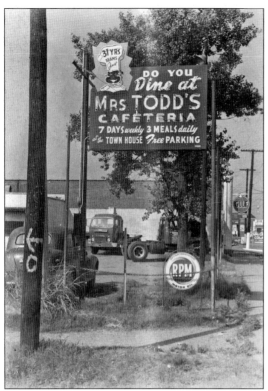

There was only one Mrs. Todd's, located in the Town House Hotel near Five Points South, but the cafeteria had these neon directional signs placed strategically at intersections through the downtown area. (Dixie Neon collection.)

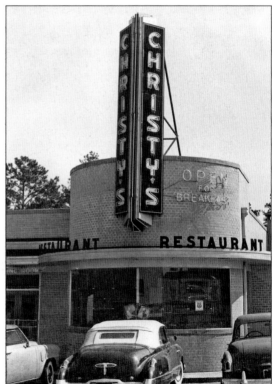

Christy's Restaurant was a landmark in downtown Homewood where U.S. 31 made its way south from Nashville toward Montgomery. (Alabama Neon collection.)

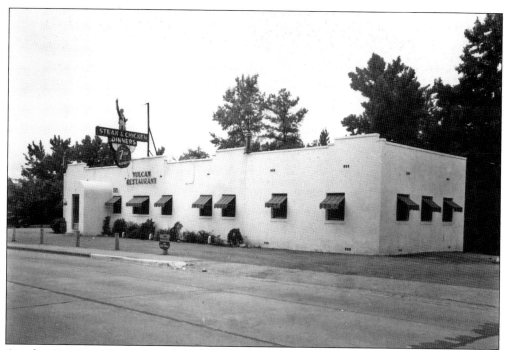

Another Homewood institution was the Vulcan Restaurant, complete with its neon rendition of Birmingham's famed "iron man." The building later spent many years as the popular Gold Nugget Restaurant and Lounge. (Birmingham Rewound collection.)

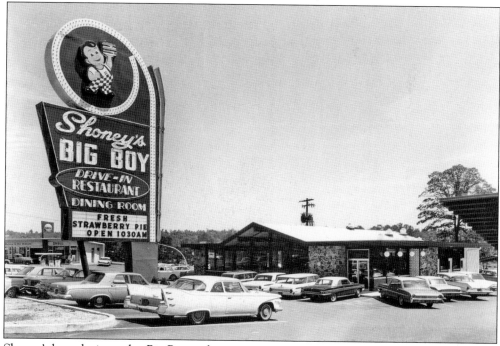

Shoney's brought its pudgy Big Boy and towering signage to several spots in Birmingham. This is the Eastwood Mall location, but almost identical ones could be found on Third Avenue West, in Midfield, and in Roebuck. (Birmingham Rewound collection.)

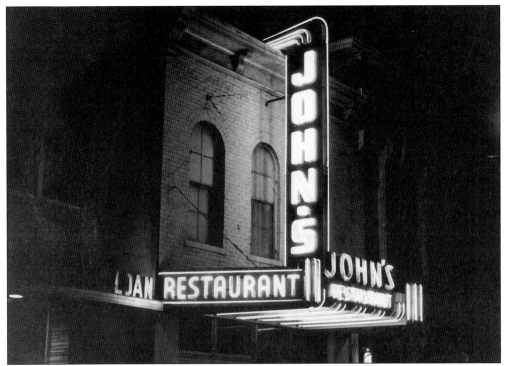

John's has survived to become one of the few 1940s restaurants still doing business downtown. Its theater-like marquee has been changed a few times but still has this same basic look. (Ace Neon collection.)

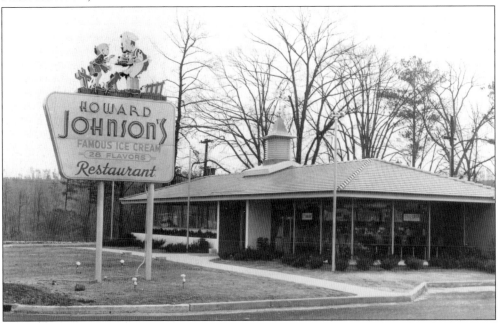

In the 1950s and early 1960s, there was no greater "landmark for hungry Americans" than Howard Johnson's. This example hoisted its Simple Simon sign near the site that would later become Eastwood Mall. (Dixie Neon collection.)

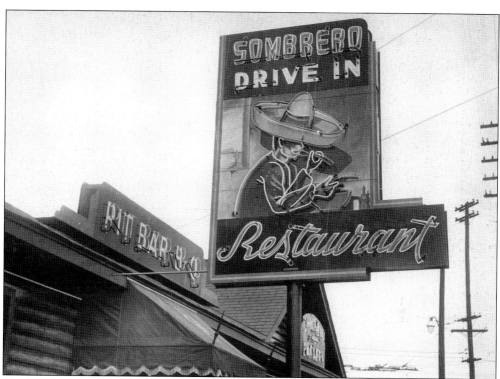

On this page, we visit a pair of long-running Five Points West restaurants. The menu at the Sombrero was not nearly as Mexican as the name would suggest, judging from its advertised specialties of pit barbecue and Chicken in a Basket. (Alabama Neon collection.)

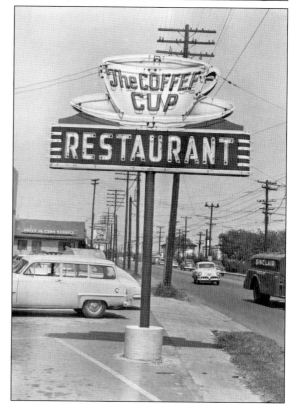

The Sombrero is visible in the background behind the Coffee Cup, which opened in the late 1940s and survived for more than 30 years. Its vaguely Oriental interior decor seemed somewhat at odds with its homey name and classic sign. (Dixie Neon collection.)

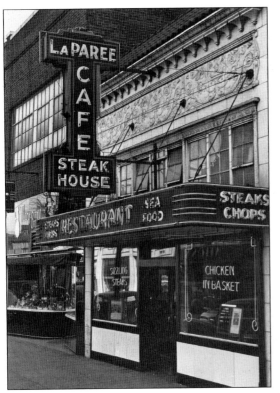

The La Paree steak house on Fifth Avenue North was a natural stop for those arriving in town via the nearby terminal station. Like the station, the La Paree is now gone, having closed in July 2003. (Alabama Neon collection.)

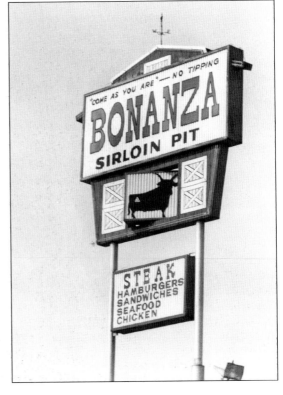

A much later example of a steak house was the chain of Bonanza "sirloin pits," with their emblem of a steer rotating inside a barn door. One could find Bonanza on the map at Hoover, Center Point, Bessemer Road, and Fifth Avenue South . . . that is, if the map did not catch on fire first. (Wes Daniel collection.)

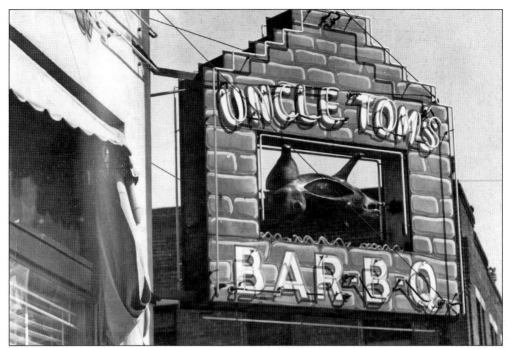

In the South, there are as many different varieties of barbecue as there are types of trees. Uncle Tom's, located at 2200 Sixth Avenue South, graphically advertised its specialty with this rotating pig on a spit. (Alabama Neon collection.)

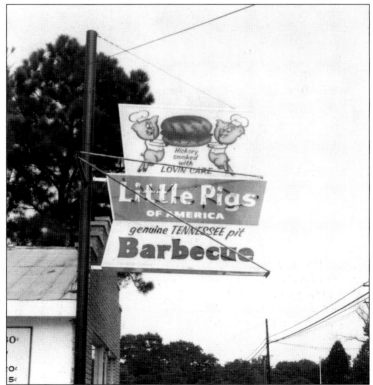

As if the many different Alabama types were not enough, Little Pigs of America brought "genuine Tennessee pit barbecue" to Cahaba Heights in the late 1960s. (Dixie Neon collection.)

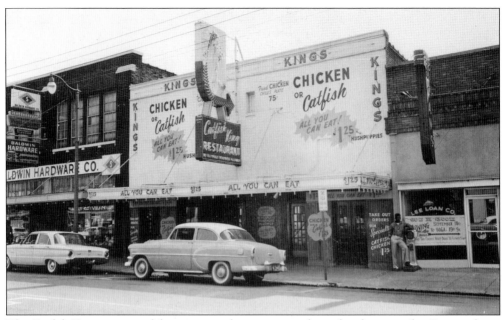

The Catfish King was one of the most popular restaurant chains headquartered in Birmingham. Locations included Ensley (pictured here), North Birmingham, and Woodlawn. There was also a downtown outlet for several years. With a deal of "all you can eat" for $1.25, how could they miss? (Birmingham Rewound collection.)

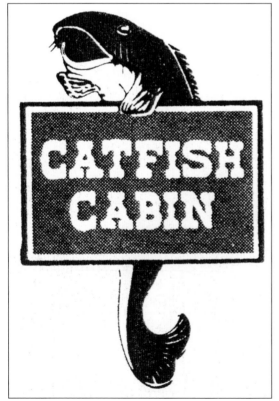

Because both signs featured a large, blue neon catfish, many people's memories still confuse Catfish King with the later Catfish Cabin chain, which was owned by the Ezell family of Ezell's Fish Camp fame. (Birmingham Rewound collection.)

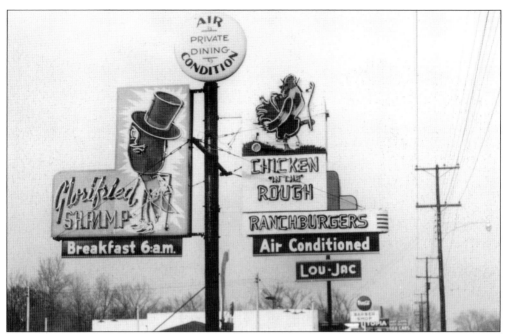

Long before Kentucky Fried Chicken, one of the most popular chains of roadside eateries was Chicken in the Rough. It was available at several Birmingham area restaurants, but this signage—also highlighting "GloriFried Shrimp"—was at the Lou-Jac on First Avenue North. (Dixie Neon collection.)

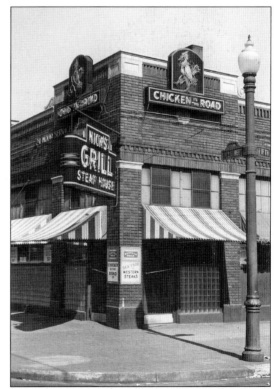

While others were roughing it with Chicken in the Rough, Nick's Grill at Fifth Avenue and Nineteenth Street featured a competing brand, Chicken in the Road. "Excuse me, sir, . . . do you prefer your chicken with or without tire tracks?" (Alabama Neon collection.)

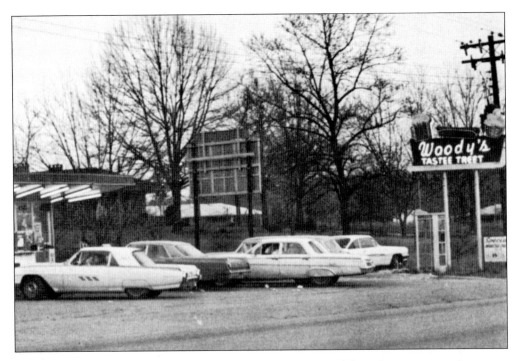

Woody's Tastee Treat (above) lured drivers off U.S. 78 in Forestdale with its neon root beer mug, hot dog, and swirled ice cream cone on the sign. Wouldn't it be nice to know what was being advertised on the billboard in the center of the photograph, with its back to the camera? In the 1970s, Woody's closed the drive-in and moved across the highway to become a full-service restaurant (below). Next door, notice the familiar boomerang-shaped arrow of the Shop-A-Snak Food Mart chain. (Todd Jones collection.)

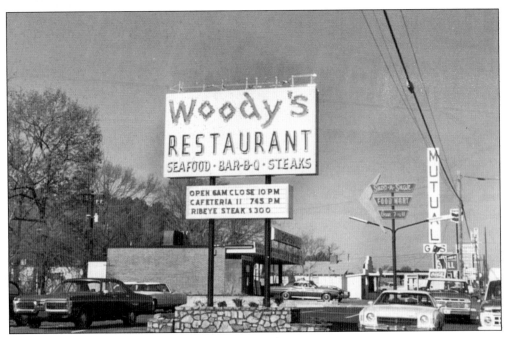

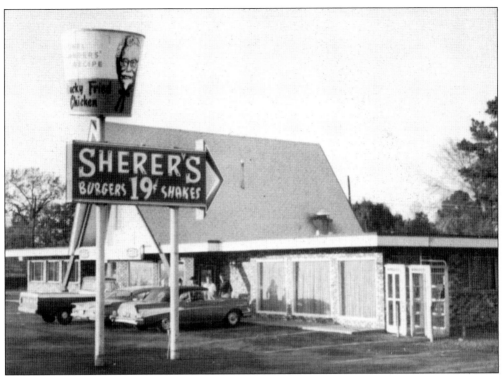

In the days before Kentucky Fried Chicken had its own chain of stand-alone restaurants, the product was featured as a specialty menu item at scores of independent eateries, including Sherer's in Graysville. (Todd Jones collection.)

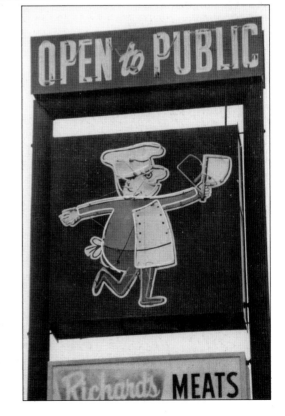

Instead of getting hamburger or chicken at a restaurant, people could bypass the middleman and visit Richard's Meats on Finley Avenue, where this animated neon butcher wielded a mean cleaver. (Birmingham Rewound collection.)

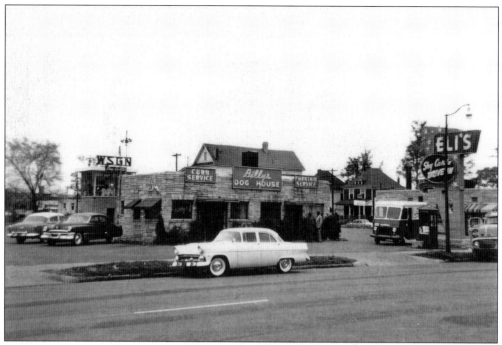

Eli Courie operated his Eli's Sky Castle Drive-In on Seventh Avenue South. As you can see, the parking lot became the location of WSGN radio's Sky Castle box, where the DJs would broadcast for a live and appreciative, and mostly teenaged, audience. (Birmingham Rewound collection.)

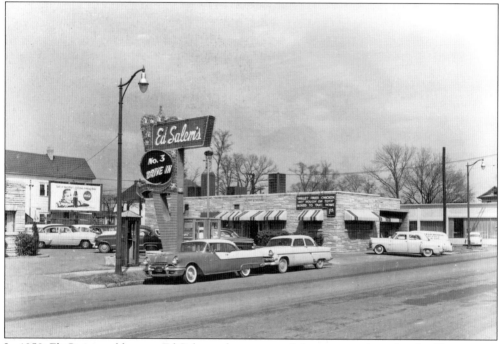

In 1958, Eli Courie sold out to Ed Salem, who converted the property into the third location in his Birmingham chain. The buildings still stood until recently when the property was cleared for condo development. (Birmingham Rewound collection.)

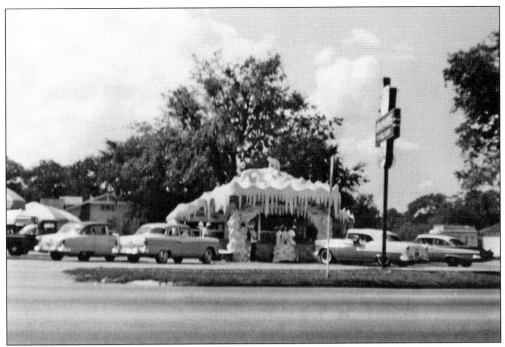

This may not be the sharpest photograph, but it is apparently the best existing one of the Spinning Wheel drive-in on First Avenue North with its concrete icicles and petrified polar bears. (Bill Coggin collection.)

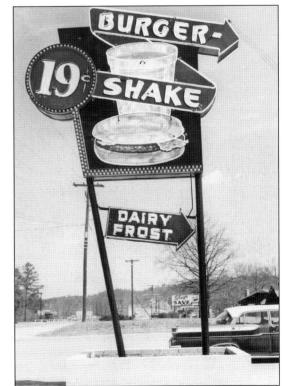

Another outlet for keeping cool during Birmingham's sweltering summers was the Dairy Frost on Eighth Avenue West near Birmingham-Southern College. A huge sign for a Mutual gas station can be glimpsed between the two support poles. (Ace Neon collection.)

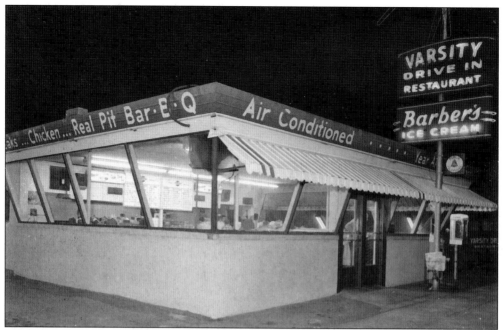

This is not Atlanta's but Birmingham's own Varsity Drive-In, located at 2016 Seventh Avenue South. The headlines on the newspaper in the rack by the door identify the date as March 5, 1963, when Patsy Cline and other Grand Ole Opry stars were killed in a plane crash after an appearance in Birmingham. (BPL collection.)

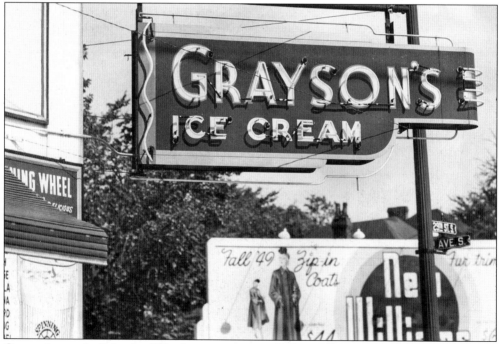

Grayson's spun its Spinning Wheel ice cream treats in shops all over town. The New Williams billboard in the background makes it easy to tell that this photograph was made in 1949. (Alabama Neon collection.)

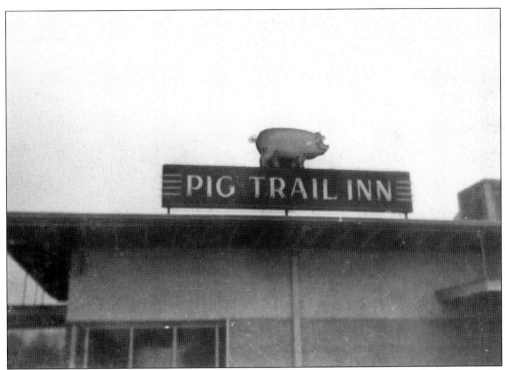

Jack Caddell's Pig Trail Inn (above) dished out barbecue in Homewood. When Caddell saw the era of fast food coming, he responded by starting the Jack's Hamburgers chain in 1960, the first location of which (below) was also in Homewood. Jack's would turn into a million-dollar company within a couple of years by throwing its entire advertising budget into Birmingham children's television hosts. (Above, Dixie Neon collection; below, BPL collection.)

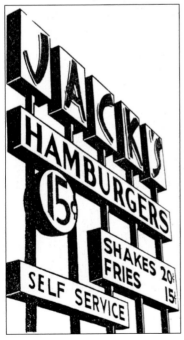

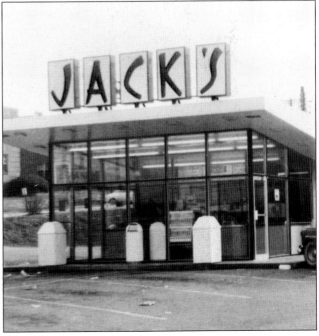

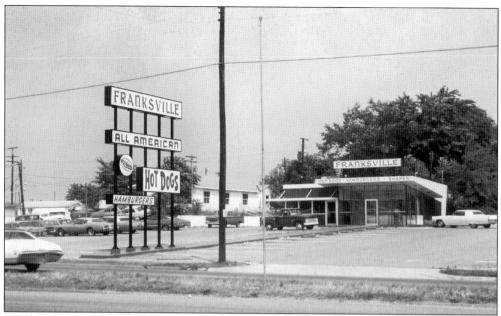

Many of the earliest Jack's Hamburgers buildings were either abandoned or modernized over the years. This one in Bessemer obviously switched its loyalty from hamburgers to hot dogs. (Dixie Neon collection.)

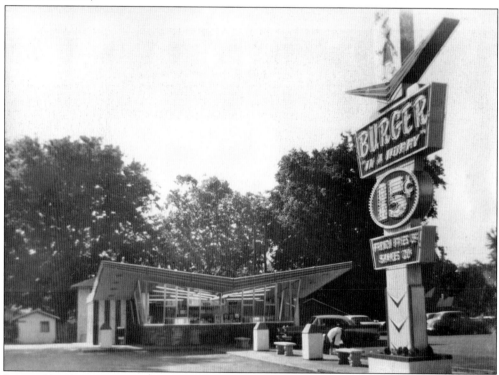

Inspired by the success of Jack's and other 15¢ hamburger chains, in 1962, Birmingham's Jim Larsen founded Burger in a Hurry where the building itself became part of the signage with its huge neon boomerangs. (Imogene Winslett collection.)

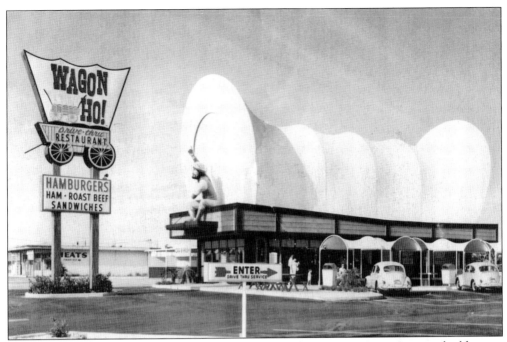

Another Birmingham entrepreneur, Temple Barnard, built his Wagon Ho! restaurant buildings to resemble huge Conestoga wagons. Each had a giant, fiberglass, Gabby Hayes look-alike manning the buckboard. (Temple Barnard collection.)

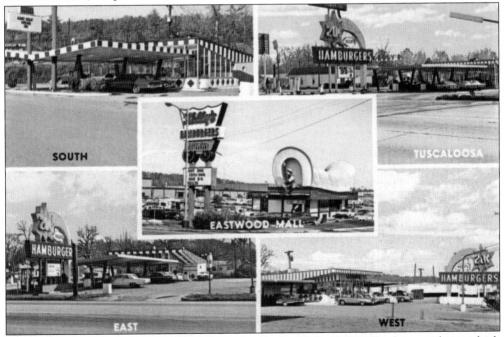

The Wagon Ho! at Eastwood Mall was later absorbed into the Kelly's Hamburgers chain, which had several other (non–covered wagon) locations in the area as well. It would seem that Kelly's rainbow-shaped signage was more than a little influenced by McDonald's and its golden arches. (Birmingham Rewound collection.)

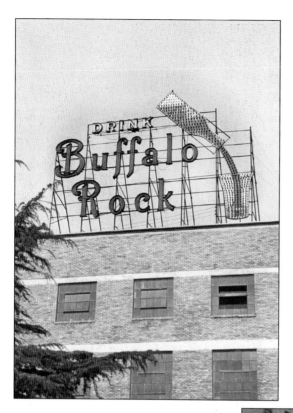

Birmingham's own Buffalo Rock ginger ale has been a popular thirst quencher since its introduction in 1901. Many people today still wonder whatever became of this lighted spectacular on the roof of the company headquarters where a bottle of Buffalo Rock consistently filled a glass over and over again. (Alabama Neon collection.)

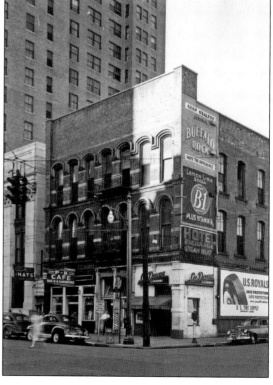

The Exchange Hotel at Morris Avenue and Twentieth Street sported these Buffalo Rock and B-1 Soda signs, which combined brick wall paintings with neon highlights. P and K Café and La Dame Cleaners were also located within the building. (BPL collection.)

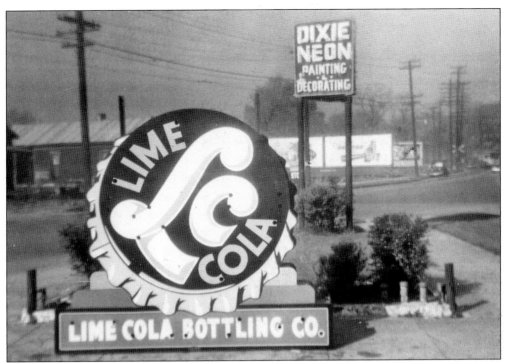

Lime Cola was a short-lived product that was born and died in 1946–1947. Its main claim to fame today is that two of the primary investors in the company were Bob Hope and Bing Crosby. This was one road they probably wished they had not taken. (Dixie Neon collection.)

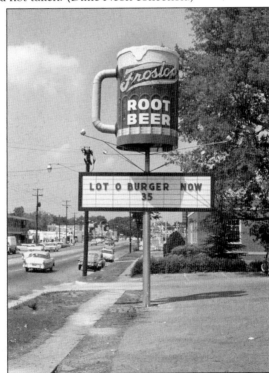

After the Frostop root beer stand on Third Avenue West closed, the handle was removed from the mug and the rest of the sign was converted into the giant lighted birthday cake logo for the Marsh Bakery. (Dixie Neon collection.)

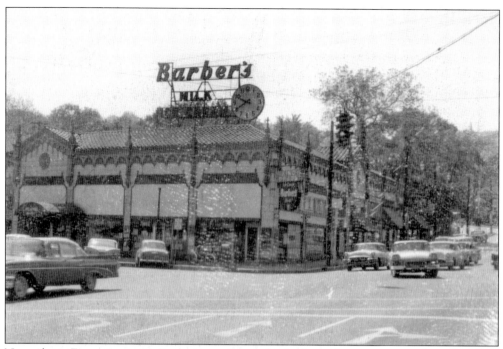

Not only are Ernest Langner's fingerprints all over this book in a figurative sense, they are also all over this photograph of the famed Barber's dairy clock at Five Points South. The sign currently sits in storage, awaiting its fate. (Dixie Neon collection.)

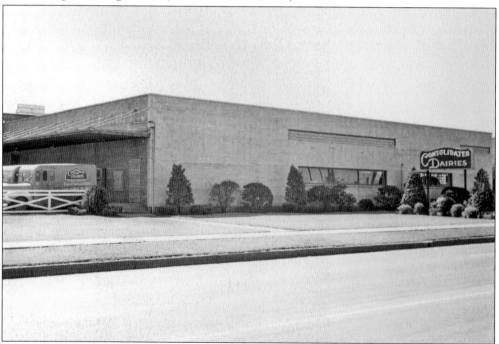

What's missing from this photograph? The cow statues that normally adorned the Consolidated Dairies lawn on Third Avenue South were apparently still out to pasture when this shot was made. (BPL collection.)

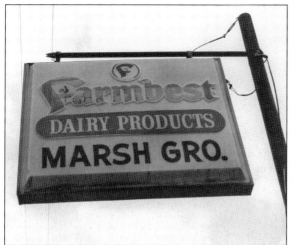
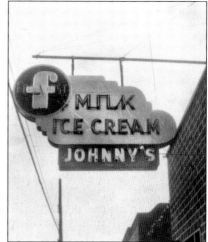

Foremost (above, right) was a long-established national dairy brand. After a government anti-trust suit caused the company to be broken up, the name became Farmbest (above, left) in Birmingham before going out of business completely. (Birmingham Rewound collection.)

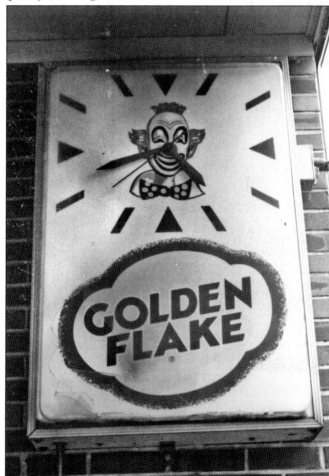

The Golden Flake clown beamed from many billboards and clocks throughout the city. One memorable billboard near the First Avenue viaduct used a giant red lightbulb as the clown's nose, but unfortunately, no photographs seem to have survived showing that spectacular sight. (Birmingham Rewound collection.)

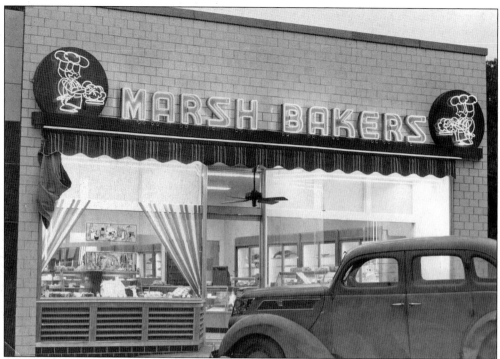

Before Marsh Bakery inherited the Frostop root beer mug and turned it into a birthday cake, the goody shop had the animated neon action of these busy bakers. (Alabama Neon collection.)

The bakery department was such a popular feature of Pizitz's downtown store that locations were opened in many outlying neighborhoods. All were under the direction of the Pizitz master chef, Kurt Hertrich. (Dixie Neon collection.)

Mention Krispy Kreme and most people start drooling like Pavlov's dogs. This was the East Lake store with the unusual sign feature of a starburst made from a doughnut. (Dixie Neon collection.)

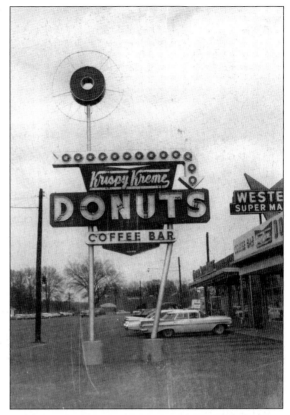

This Krispy Kreme at Five Points West illustrates the later and more familiar version of the sign with its crowned double K's and red-and-green neon zigzags. Are you hungry yet? (Dixie Neon collection.)

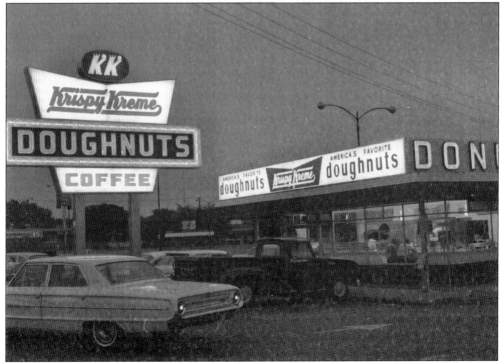

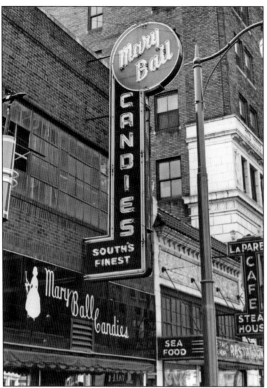

Now it's time for dessert! Mary Ball Candies were a Birmingham tradition, as seen at this Fifth Avenue North location next door to the La Paree steak house. (Alabama Neon collection.)

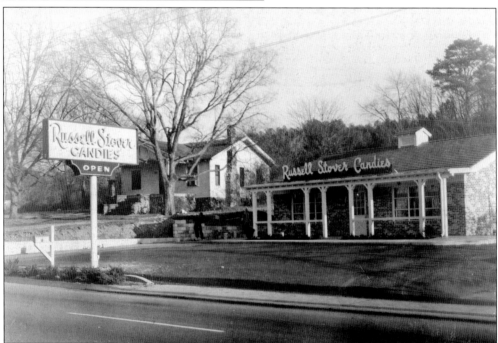

Russell Stover opened a roadside candy shop along U.S. 11 in Roebuck in the tradition of Stuckey's and Saxon's. The building still stands virtually unchanged but now serves as a title loans office. (Dixie Neon collection.)

Three

SOUTHERN COMFORT

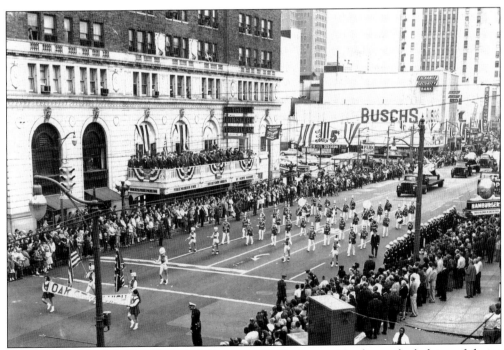

The Tutwiler Hotel (left) at Twentieth Street and Fifth Avenue North was the lodging of choice for visiting notables from 1916 until its demolition in 1974. Today's Tutwiler Hotel is an even older building that was originally constructed as the Ridgley Apartments in 1914. (BPL collection.)

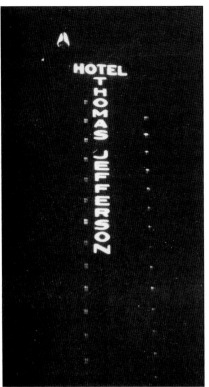

The Thomas Jefferson Hotel on Second Avenue North was built in 1927. It was later known as the Cabana and is currently undergoing renovation into the Leer Tower condominiums. Under all of its identities, the huge rooftop beacon served as its most identifying feature. (Birmingham Rewound collection.)

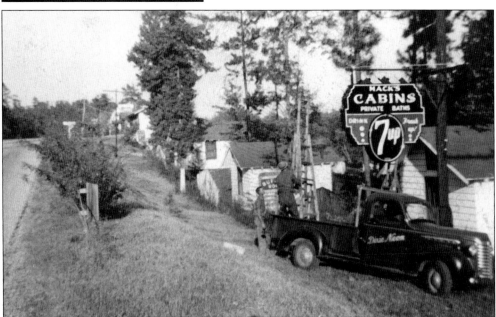

As its name suggests, the "Florida Short Route" was the primary highway out of Birmingham for those who were heading for the resorts on the Atlantic Ocean. It is today known as the congested U.S. 280 where people no longer need these quaint tourist cabins because they can get plenty of sleep behind the steering wheel of their car while waiting for the traffic to move. (Dixie Neon collection.)

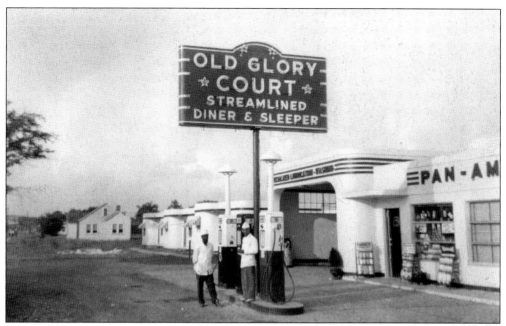

The Old Glory was one of several tourist courts along the Bessemer Super Highway (U.S. 11) as it entered and departed Birmingham from the southwestern corner of the city. (Dixie Neon collection.)

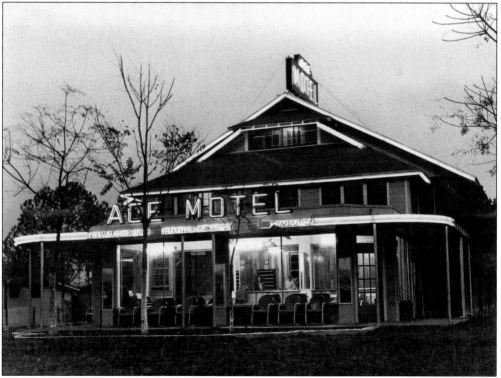

In contrast to the relatively simple tourist cabins along the Bessemer Super Highway, the Ace Motel smothered itself in neon signage and trimmings. (Alabama Neon collection.)

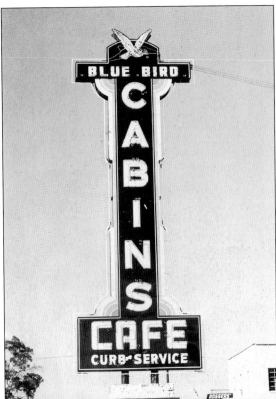

No one knows if tourists found happiness at the Blue Bird Cabins, but its tall sign was enough to make anyone consider stopping there on their way south for the winter. (Ace Neon collection.)

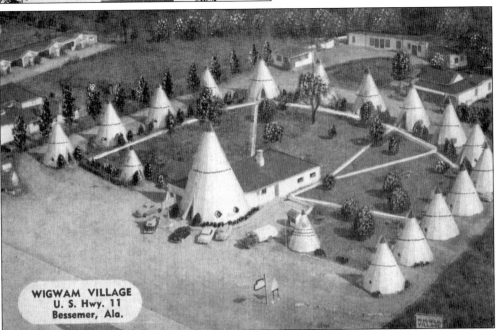

WIGWAM VILLAGE
U. S. Hwy. 11
Bessemer, Ala.

No motel or tourist court on the Bessemer Super Highway was as legendary or as much a landmark as the Wigwam Village. It was built in 1948 as the fifth location in a chain based in Cave City, Kentucky. (Warren Reed collection.)

The first Holiday Inn in Birmingham opened in 1954. The size of the "Great Sign's" trademark starburst can be gauged by the workmen seen installing it here. (Dixie Neon collection.)

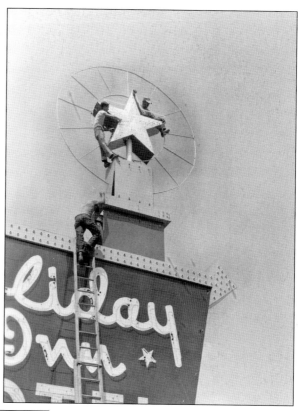

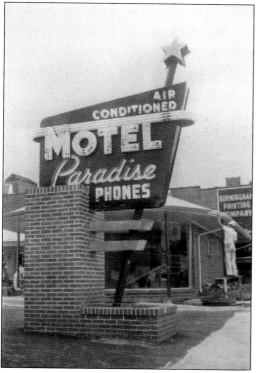

One would think the Paradise Motel on U.S. 31 was copying the Holiday Inn sign. But this photograph was taken on July 17, 1952, one month before the first Holiday Inn opened in Memphis, Tennessee. The Paradise was eventually lost; the Red Mountain Expressway now joins I-59/20 over its former site. (Dixie Neon collection.)

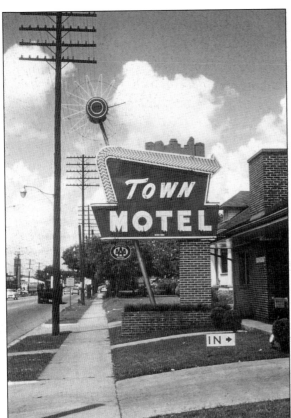

The Town Motel on Third Avenue West still stands as of this writing. At left in the distant background, the tall pylon and sign of the 7-Up bottling plant are barely visible. (Dixie Neon collection.)

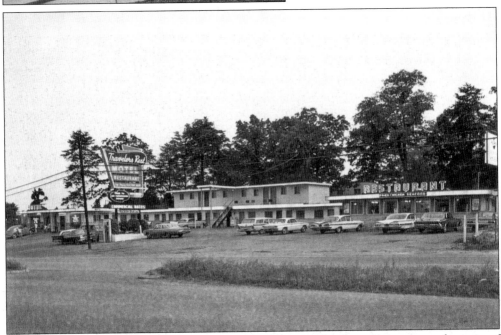

On U.S. 78 in Forestdale, the signage for the Traveler's Rest motel and restaurant appeared in a riot of multiple colors. The Holiday Inn influence on the sign is obvious. (Warren Reed collection.)

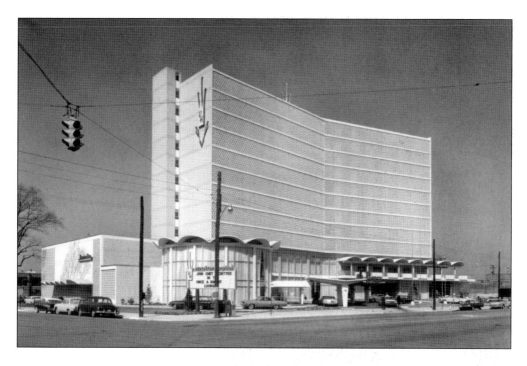

A new generation of downtown lodging arrived with the opening of the Parliament House on Twentieth Street in 1964. With its space-age design and aquamarine coloring, the hotel looked as if it had just wandered into town from one of the Florida beaches. After suffering declining fortunes for many years, the much-neglected structure was purchased by the University of Alabama at Birmingham (UAB) and scheduled for demolition. (BPL collection.)

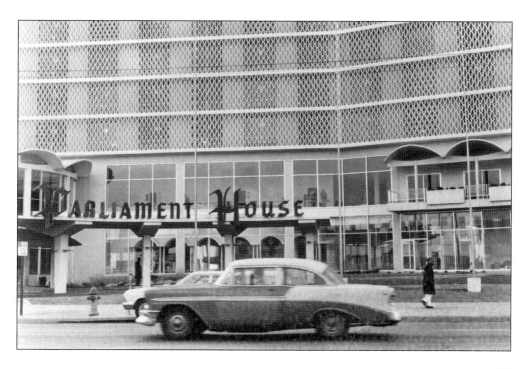

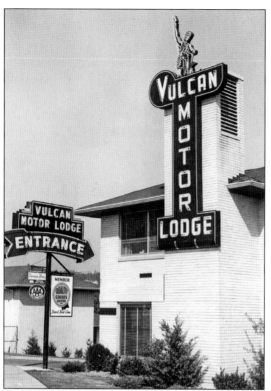

Tourists had no doubt that they were indeed in Birmingham, and not Atlanta, Chattanooga, or Nashville, when the image of Vulcan began turning up in neon form. This motel could be found on U.S. 31 just after the highway snaked its way across Red Mountain and passed directly beneath Vulcan's stone pedestal. (Alabama Neon collection.)

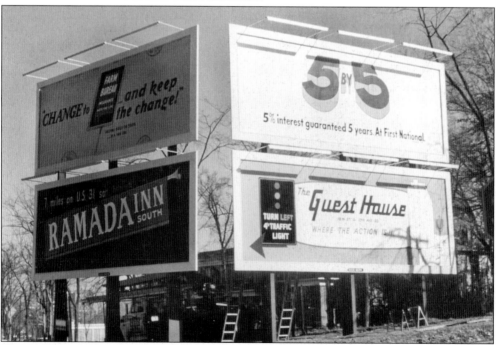

This conglomeration of billboards gives us a chance to acknowledge at least two more Birmingham lodging landmarks, the Ramada Inn in Hoover and the Guest House, which was in the middle of what would later become the UAB medical complex. (Dixie Neon collection.)

Four

ON THE ROAD AGAIN

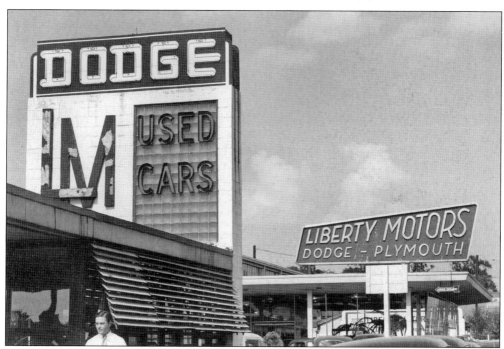

Some people claim that Birmingham had more automobile dealerships than any other city its size. This section will visit some of those and also show some of just what kept those cars running. (Alabama Neon collection.)

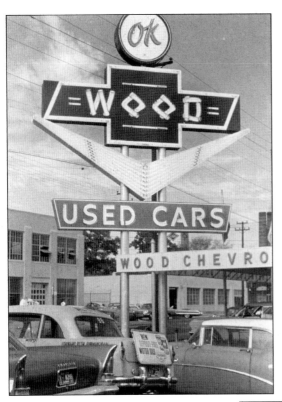

With so many car dealerships in town, every single one of them tried to find a way to stand out from the rest. It helped if they had a name like Wood Chevrolet, which could use neon to make its lettering look like fallen timber. (Dixie Neon collection.)

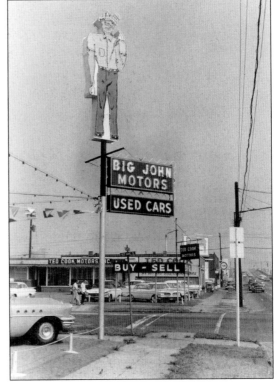

This used-car dealership on Southside was certainly trying to be topical. This sign undoubtedly dates from around 1962, the year Jimmy Dean had a hit record with his coal mining song "Big Bad John." The fact that Birmingham was surrounded by coal mines could do nothing but help the connection. (Dixie Neon collection.)

"Sorrowful" Jones, a used-car dealer across Twentieth Street from the Hillman Hospital, wept neon tears on his well-remembered, sad-faced sign. (Dixie Neon collection.)

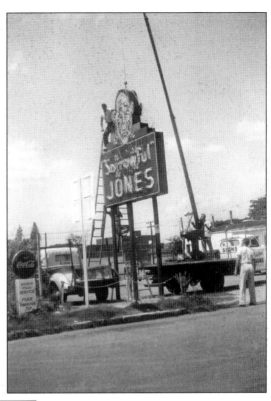

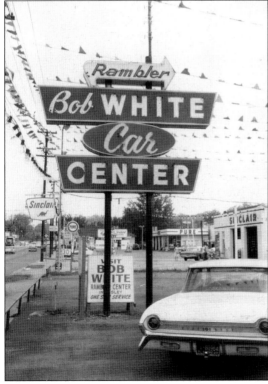

Despite the best efforts of the Bob White Car Center on Avenue D in Ensley, the Rambler automobile eventually went the way of the dinosaur on the Sinclair service station sign next door. (Dixie Neon collection.)

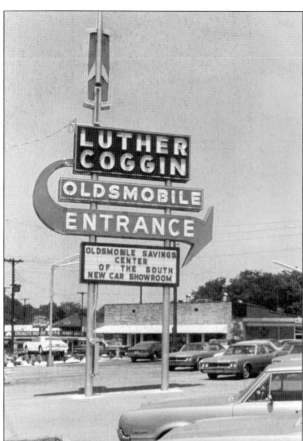

Luther Coggin set up his Oldsmobile lot at Five Points West; notice the neon pigs of Crumly's Barbecue in the distant background. (Dixie Neon collection.)

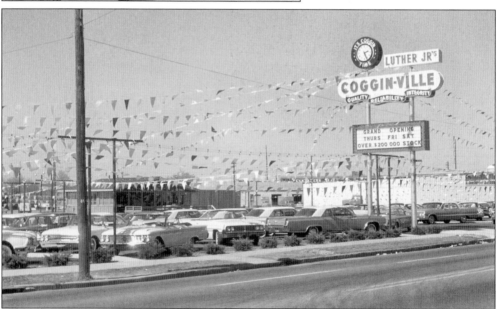

A chip off the old engine block, Luther Coggin Jr. opened his own "Coggin-Ville" and festooned the lot with multicolored plastic flags. (Dixie Neon collection.)

Car shoppers no doubt got more bang for their buck at TNT Cars. Let's just hope that the motors didn't blow up before the cars reached the end of the driveway. At any rate, the prices must have been dynamite. (Dixie Neon collection.)

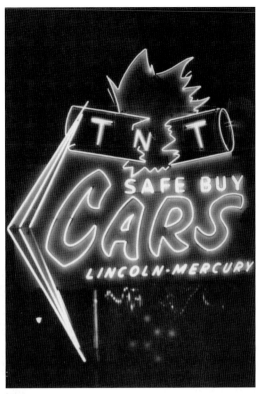

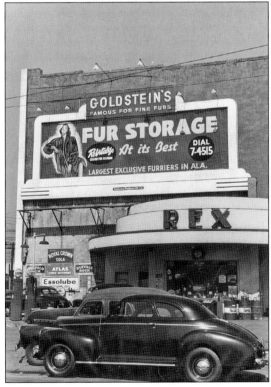

Take a good look at the vintage oil company signs and products surrounding this service station, then let your gaze linger a while longer on the Goldstein's billboard above. Both are truly sights you will not see today. (Alabama Neon collection.)

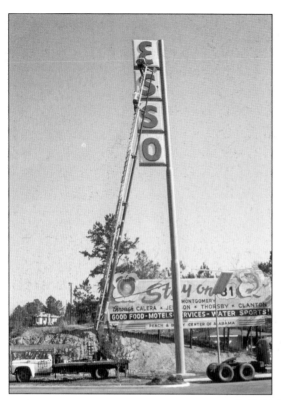

The billboard next to this Esso service station sign was encouraging motorists to stay on reliable, faithful old U.S. 31 instead of taking that newfangled Interstate 65. Hardly anyone listened to such an appeal. (Dixie Neon collection.)

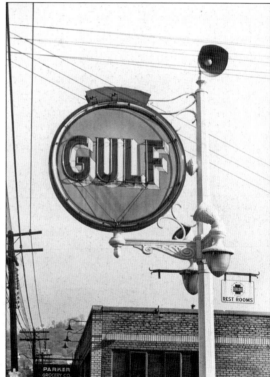

Even a relatively simple sign could be a thing of beauty. In this close-up view of the logo at a Gulf service station, notice the detailing on the sign supports and the holders for the floodlights. (Alabama Neon collection.)

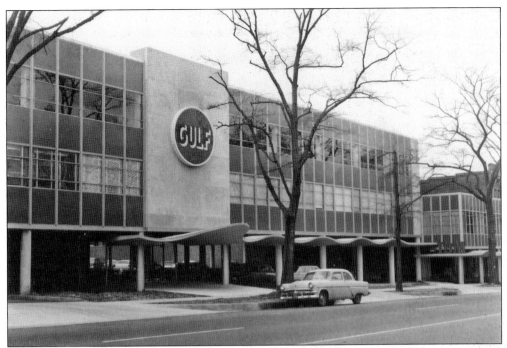

Gulf Oil's regional offices on Highland Avenue were a familiar sight with the orange Gulf disc contrasting with the teal panels on the front of the building. The sign would later be changed to reflect Gulf's evolving logo in the 1960s. (Dixie Neon collection.)

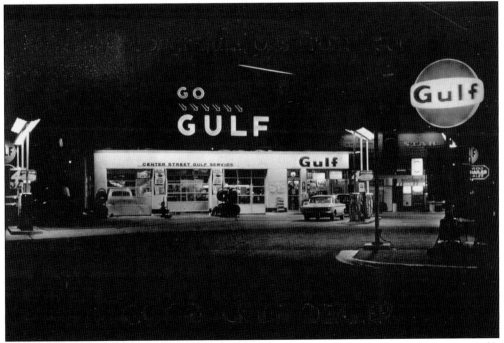

There could be no better example of the 1960s-style Gulf station with its flashing "Go Gulf" rooftop sign and arrows than this one on Center Street near Legion Field. (Birmingham Rewound collection.)

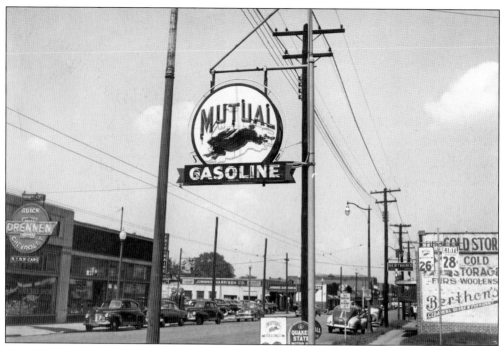

The Mutual service stations with their bunny logo and discount rates are what gave rise to the term "rabbit gas." With today's gas prices, 26¢ per gallon doesn't sound like much lettuce. (Alabama Neon collection.)

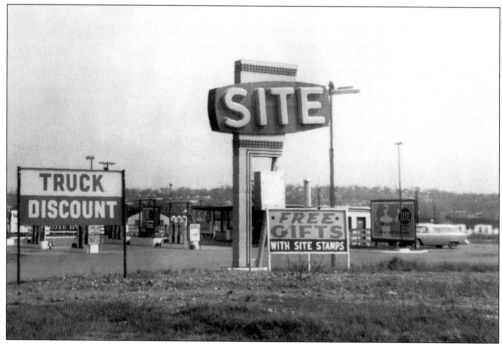

Another discount gas brand was Site, the East Thomas location of which is shown here. Site's space-age yellow-and-blue signage was one of its most distinctive features. Like many gas discounters, Site offered its own brand of trading stamps to attract customers. (BPL collection.)

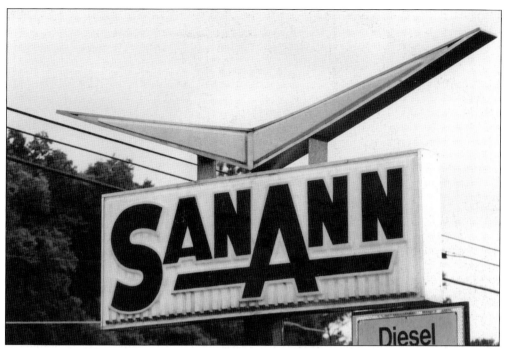

SanAnn and its blue-green boomerang benefited greatly from sponsoring popular radio personality Joe Rumore. There were still a few surviving SanAnn locations into the 1990s. (Birmingham Rewound collection.)

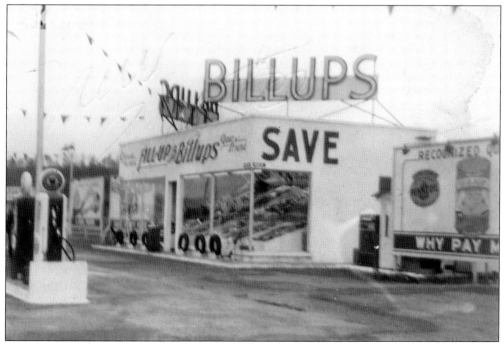

"Fill up with Billups" was the slogan used by yet another of the cut-rate gas station chains. Billups's other emblem was the image of an outstretched hand with the motto "Your Friend." (BPL collection.)

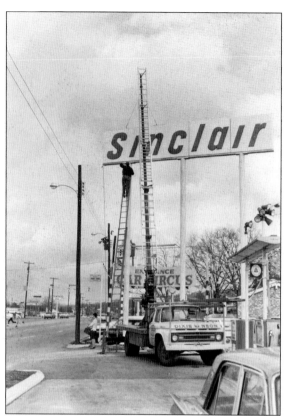

The Dixie Neon crew drove out to Roebuck to install this 1960s-model Sinclair signage. For once, the familiar green Sinclair dinosaur was nowhere to be seen, although a traveling exhibit of the dinosaurs from Sinclair's 1964 World's Fair Exhibit did later make a stop at the Roebuck Shopping Center. (Dixie Neon collection.)

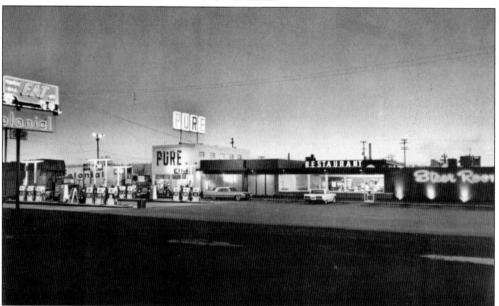

Pure Oil's truck stop on U.S. 78 was a sight to see after dark. The wheels on the red-and-green neon "EAT" truck were animated, and the lighting on the Steer Room restaurant sign was inviting enough to make just about anyone want to pull in and chew their cud for a while. (Birmingham Rewound collection.)

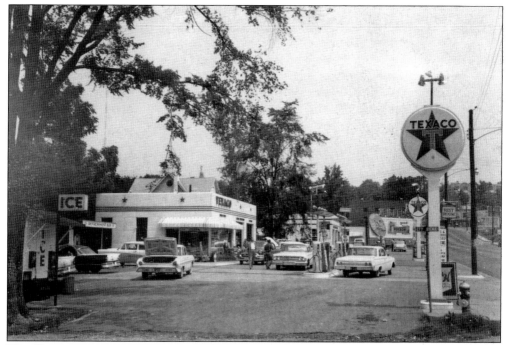

This Texaco station on Twenty-Seventh Avenue in Homewood was a splendid example of the chain's 1960s style before a fake rock-work front was adopted toward the end of the decade. Notice the billboard for Zeigler's meats in the distance. (Dixie Neon collection.)

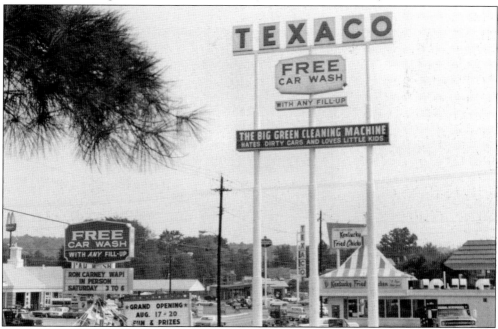

Texaco's "Big Green Cleaning Machine" on Montclair Road shared its neighborhood with one of the classic, striped, pagoda-roofed Kentucky Fried Chicken outlets. Of special note is that WAPI radio personality Ron Carney is advertised as making an appearance for the car wash's grand opening. (Dixie Neon collection.)

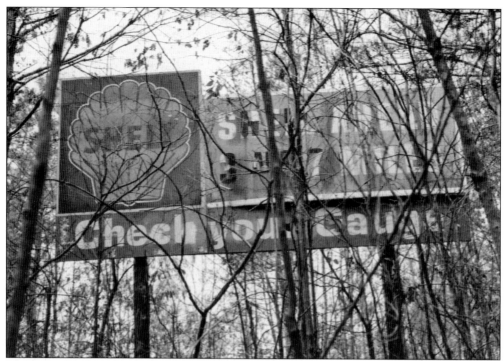

This long-abandoned and forgotten Shell billboard was found among the trees along U.S. 78 near Graysville in 1991. (Birmingham Rewound collection.)

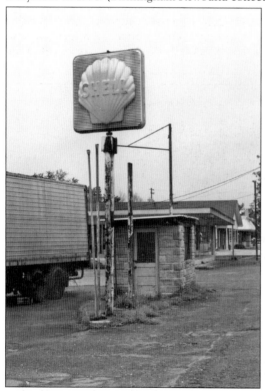

Shell later converted its logo to the more abstract representation of a seashell that it uses today, but the older signage was considerably more detailed. This fading example stood alongside U.S. 11 in Trussville. (Birmingham Rewound collection.)

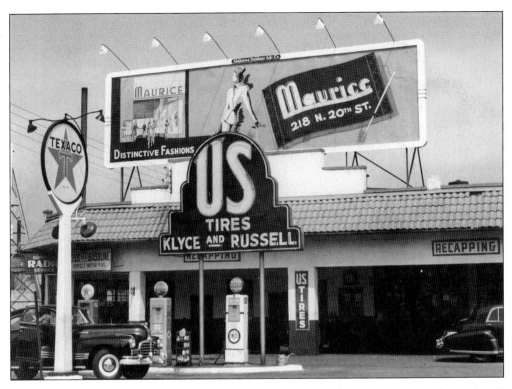

Obviously, those cars wouldn't go far without tires, so dealerships such as U.S. Tires (above) and OK Tires (below) were ready to tread the roads along with their customers. As a somewhat jarring contrast, the fashionable Maurice clothing store on Twentieth Street got into the act with yet another combination billboard and neon sign (above). (Above, Alabama Neon collection; below, Dixie Neon collection.)

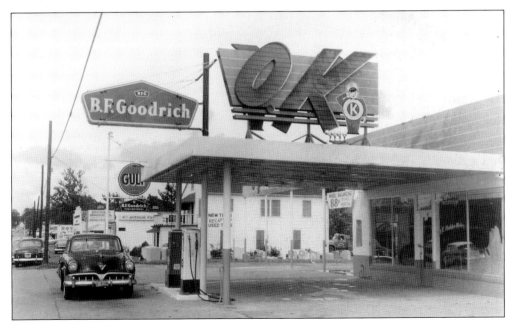

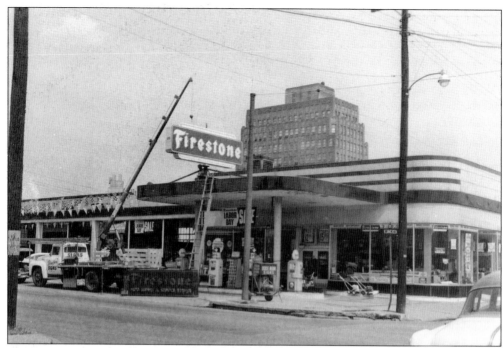

Here we see the Dixie Neon crew on the job in Ensley, swapping a new Firestone sign for an older style (visible on the ground by the truck). Towering over everything is the Ramsay-McCormack building, the tallest structure in Ensley. (Dixie Neon collection.)

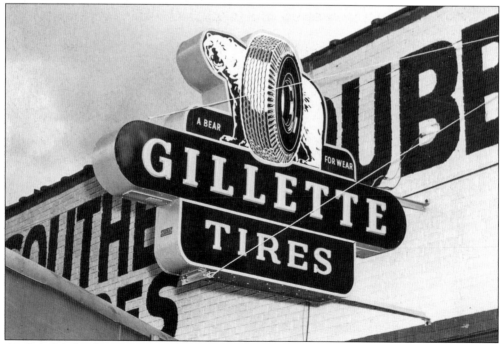

As their familiar logo was fond of pointing out, Gillette tires were "a bear for wear." Uniroyal's brand of "Tiger Paw" tires would join Gillette in the automotive supplies jungle. (Alabama Neon collection.)

Without a doubt, the most visible traffic emblem in Birmingham was Vulcan's neon torch, installed in October 1946. As most people know by now, it glowed green unless there was a traffic fatality in the city, upon which it burned red for 24 hours. (Dixie Neon collection.)

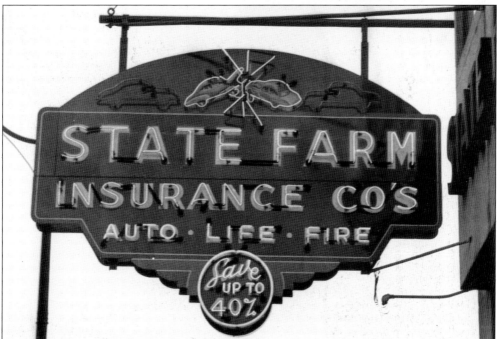

Through the magic of neon animation, this State Farm sign demonstrated graphically just the sort of accident that could make Vulcan's torch turn red—and what was worse, the head-on collision occurred over and over again, all night long. (Ace Neon collection.)

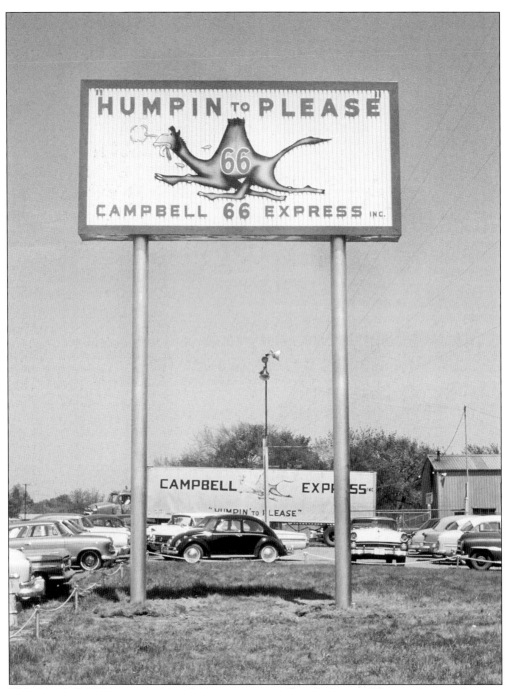

The Campbell 66 Express trucks with their panting trademark, Snortin' Norton the camel, were a familiar sight on the highways. Here we see one of them departing Campbell's terminal on Finley Avenue, mirroring the company's sign above. Another rendition of Snortin' Norton appeared as a mural painted on the brick front of the terminal building. (Dixie Neon collection.)

Five

ALL PLAY AND
NO WORK

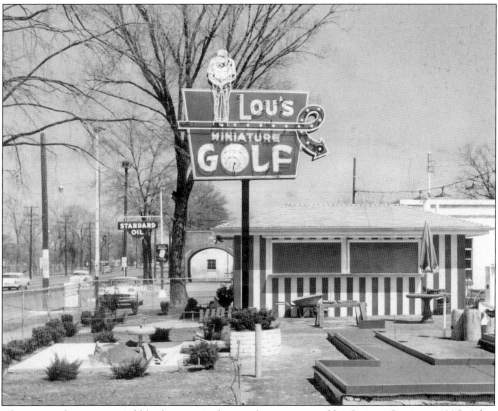

The game of miniature golf (at least as we know it) was invented by Garnet Carter in 1925. After becoming a craze during the Great Depression, its popularity died out until it was reborn in the postwar baby boom era. Lou's Miniature Golf in Woodlawn was one of the new breed of courses, with a flashy animated neon sign as part of the bargain. (Ace Neon collection.)

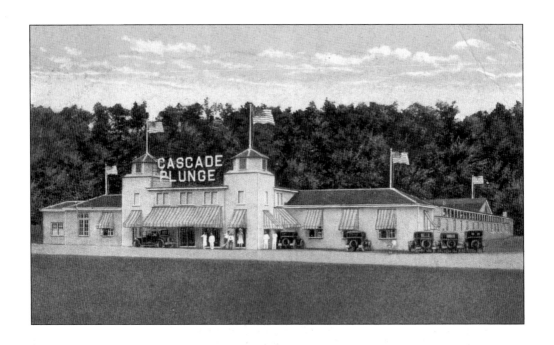

For those who liked to spend their leisure time by getting soaked to the skin, Birmingham offered the choice of the huge Cascade Plunge swimming pool in East Lake (above) or the sandy, white, simulated beaches of Holiday Beach near Bessemer (below). Holiday Beach received its name because the owner was also the first Holiday Inn franchisee in town. (Above, Warren Reed collection; below, Dixie Neon collection.)

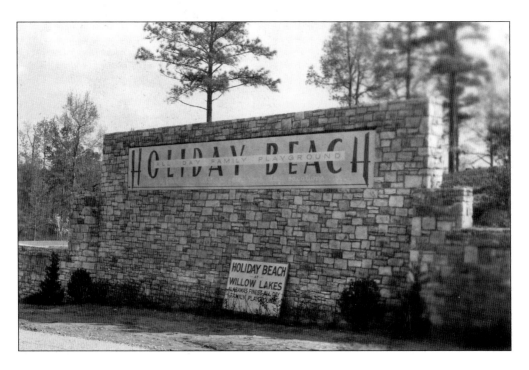

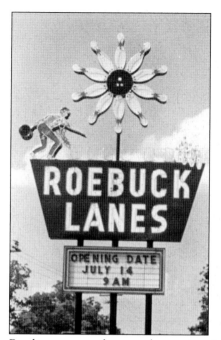
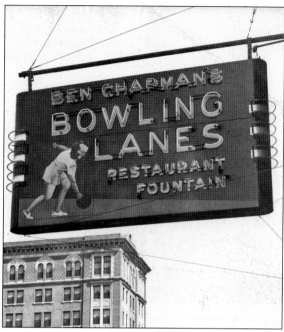

Bowling was another popular pastime in the postwar world. Roebuck Lanes, another business enterprise of Ed Salem's, did fine with its animated bowler, but one has to wonder about the artist who painted the troll-like woman on Ben Chapman's sign (above, right). (Alabama Neon collection and Dixie Neon collection.)

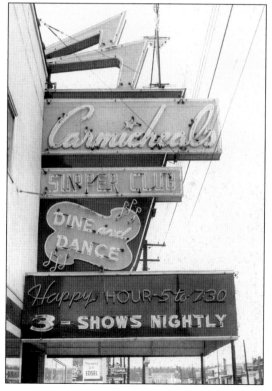

Dining, dancing, and live entertainment were the staples of Carmicheal's Supper Club in Homewood. The nightspot hosted some of the biggest stars in the entertainment world. Less successful was the Edsel automobile, being promoted on the sign just visible under Carmicheal's projecting marquee. (Ace Neon collection.)

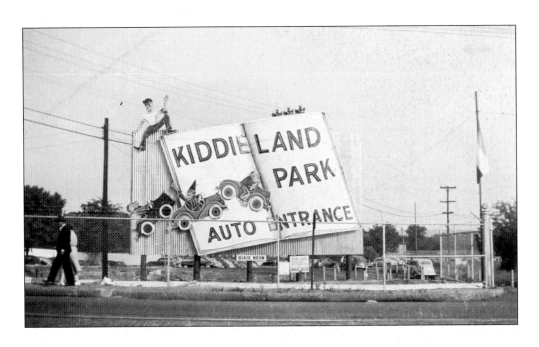

Around the time the city of Birmingham took over operation of the Alabama State Fairgrounds in 1947, the new Kiddieland Park was erected near the shoulder of U.S. 11. Dixie Neon contributed its talents to the entrance signage with a plethora of animated figures surrounding the gates. (Dixie Neon collection.)

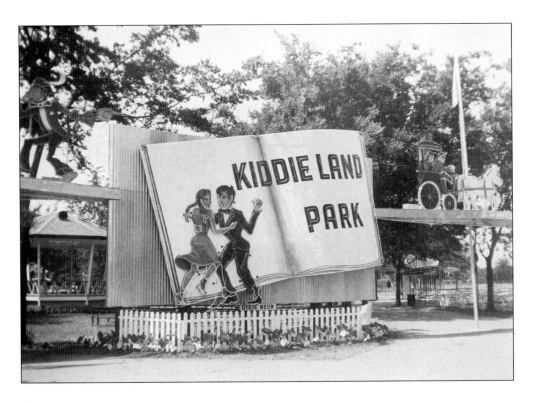

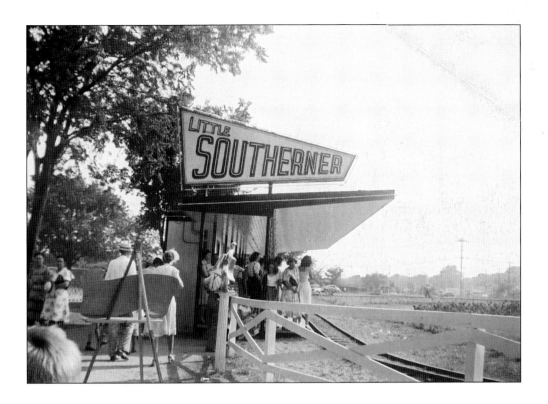

Some of Kiddieland Park's original late-1940s rides were still there into the early 1980s. These priceless shots capture two of the best-remembered ones for posterity, the Little Southerner miniature railroad (above) and the Laff in the Dark fun house (below) with its clown face that blinked from smiling to crying. (Dixie Neon collection.)

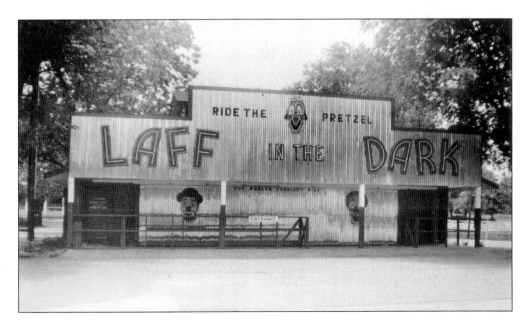

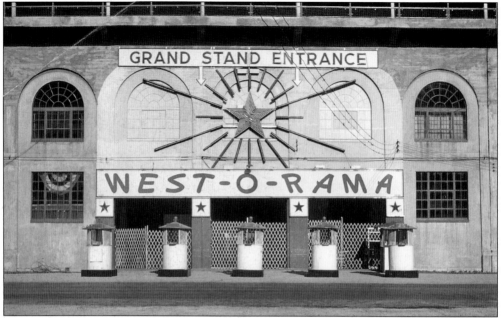

During the 1950s, the fairgrounds' main grandstand received this Holiday Inn–inspired flashing star with radiating multicolored rays. This photograph was made in 1957 when a traveling show called the "West-O-Rama" was appearing at that year's fair. (Dixie Neon collection.)

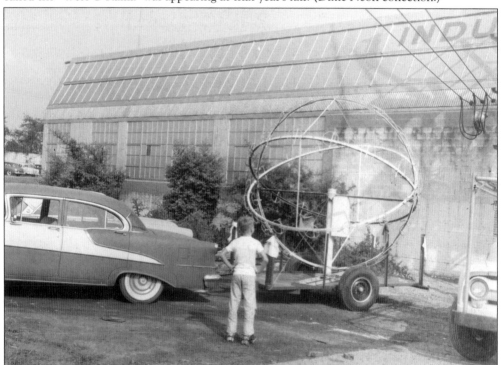

Another project for Dixie Neon was the huge model of an atom that rose above the Industrial Arts building. Its animated electrons encircled a giant lighted nucleus. The boy watching the sign's installation here gives a good indication of its size. (Dixie Neon collection.)

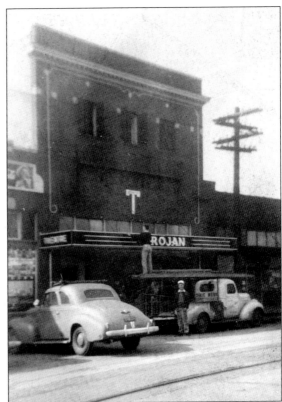

Seemingly every neighborhood in Birmingham had its own small movie theater to serve those who were unwilling or unable to travel to the larger downtown movie houses. The Trojan Theatre (pictured right) was in Brighton; the location of the Woodlawn Theatre (pictured below) is given away by its name. (Dixie Neon collection.)

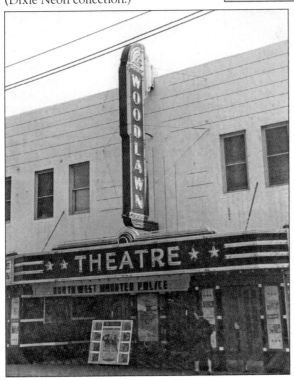

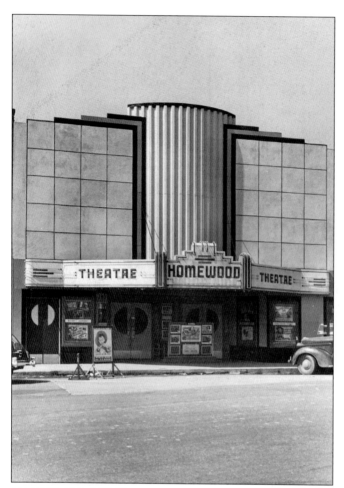

The Homewood Theatre was a most distinctive piece of architecture along U.S. 31. The building looks almost exactly the same today except that it now contains a bicycle shop instead of showing films. (Alabama Neon collection.)

The Green Springs 4 was one of the first multi-screen theaters ever seen in Birmingham. The building had formerly served as a bowling alley and as a department store before being carved up into a multiplex. (Dixie Neon collection.)

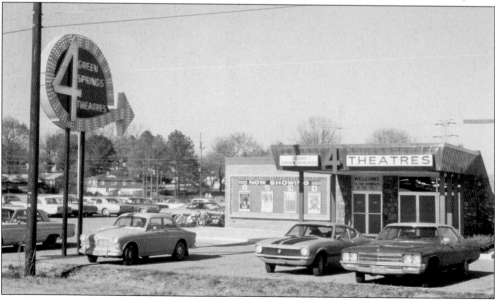

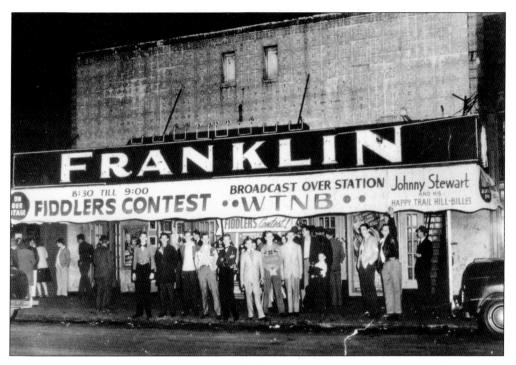

As one of Birmingham's steelmaking centers, Ensley developed its own burgeoning theater and retail district. Two of its prominent movie houses were the Franklin (pictured above), which was later converted into the Catfish King restaurant seen on page 46, and the lavish Ensley (pictured below), which spent most of its later life as a drugstore. (Birmingham Rewound collection.)

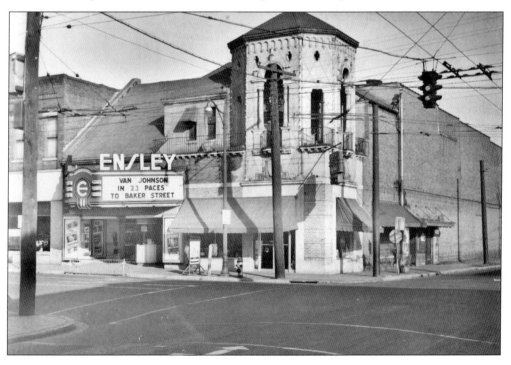

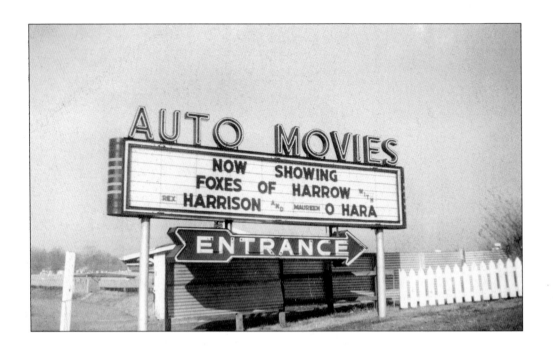

Like miniature golf, drive-in movies had been around for a long time but really became popular in the late 1940s and early 1950s. Auto Movies No. 1 on the Bessemer Super Highway (above) and the Fair Park Drive-In adjacent to the fairgrounds and Kiddieland Park were only two of the many outdoor movie venues available in town. (Dixie Neon collection.)

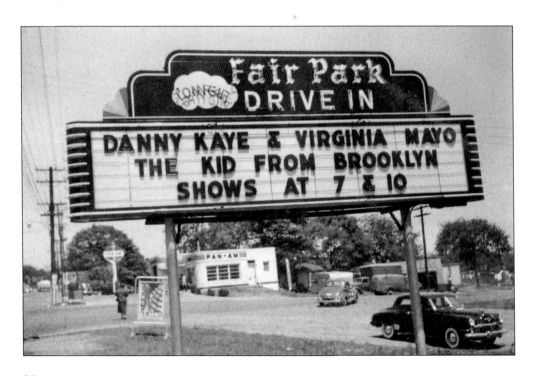

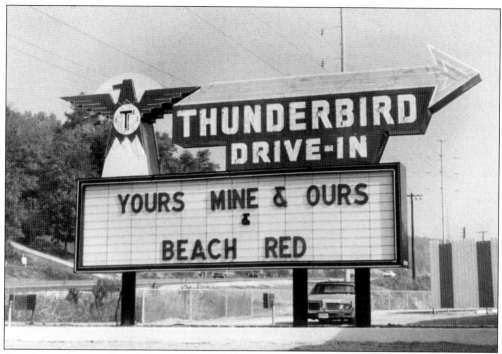

Another well-remembered drive-in theater, the Thunderbird, spread its wings next to U.S. 31 in Vestavia. Faced with declining audience interest and escalating property value, the Thunderbird flew the coop in 1977. (Dixie Neon collection.)

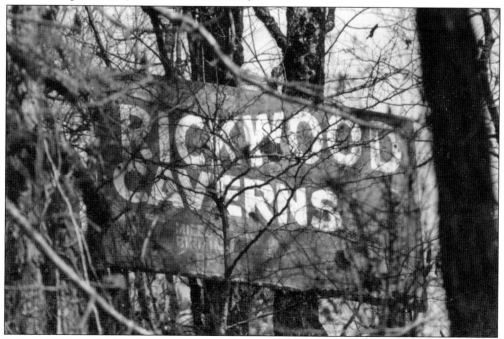

In the days before it became a more dignified state park, Rickwood Caverns plastered the surrounding area with its metal red-and-white billboards. This was possibly the only surviving one when discovered and photographed in Fultondale in 1996. (Birmingham Rewound collection.)

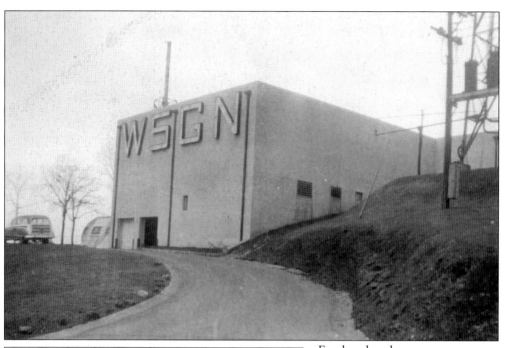

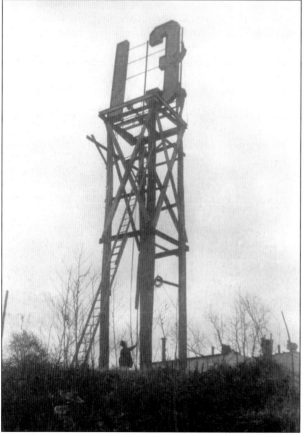

For decades, there was no Birmingham radio station that even approached the popularity of WSGN. When this photograph was made in the early 1950s, WSGN had recently moved into new studios atop Red Mountain, a structure that would soon become home to the Channel 13 television studios. (Dixie Neon collection.)

Since the crest of Red Mountain could be seen from almost any part of town, Channel 13 advertised its presence with a huge representation of its number mounted on a tower. The competition would get an idea from seeing that, as can be seen on the next page. (Dixie Neon collection.)

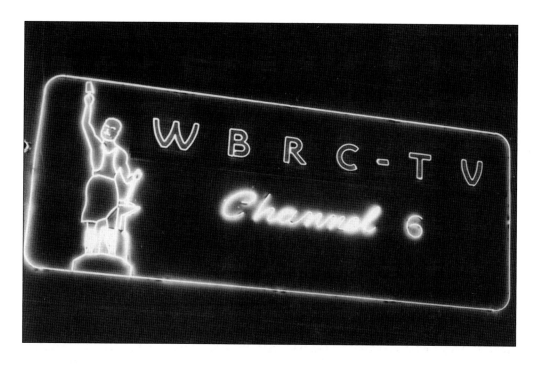

WBRC-TV stole a bit of Channel 13's thunder with its own neon billboard, complete with its own version of Vulcan (above). In September 1954, WBRC hired Dixie Neon to create what would become a true Birmingham icon: a set of its call letters overlooking each side of Red Mountain (below). At the time, the letters blinked to the channel number 6 and back again, but today they simply glow steadily and no longer flash. (Dixie Neon collection.)

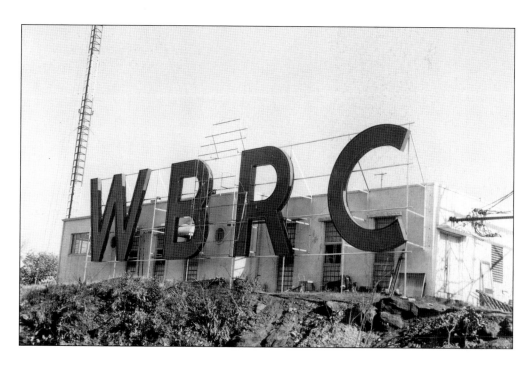

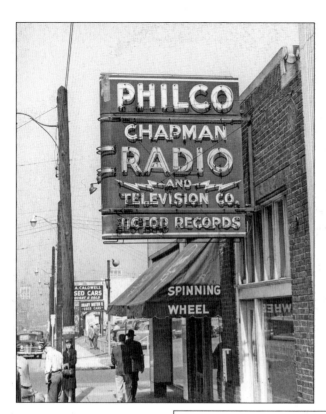

Chapman Radio and Television not only sold entertainment equipment, but also got into the medium personally, starting radio station WCRT. (Alabama Neon collection.)

Godwin Radio on Fourth Avenue South also got into radio station ownership with WEZB. The huge, lighted, boomerang arrow on the sign long outlasted the station, remaining even after Long's Electronics moved into the building. (Birmingham Rewound collection.)

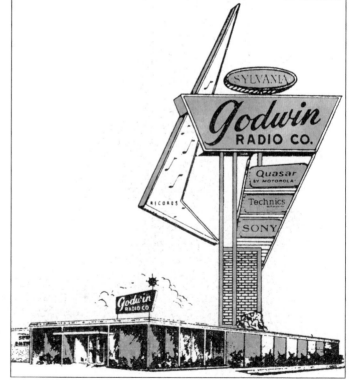

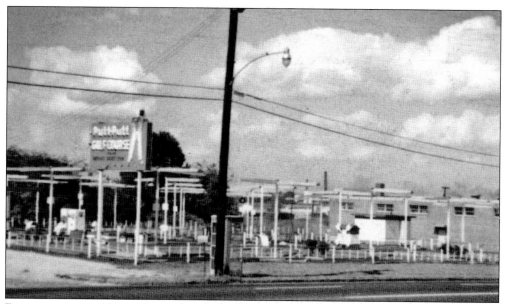

Even miniature golf was subjected to the same chain business mentality that was sweeping the rest of the country. According to the owner, Jim Hatcher, the Putt-Putt Golf on Third Avenue South was one of only two courses in the national chain to feature the animated neon putter on its sign. (Jim Hatcher collection.)

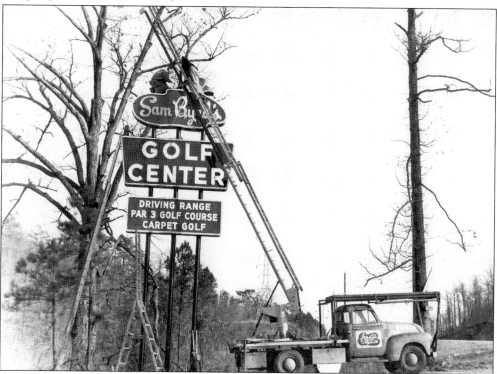

Golf courses of the non-miniature variety had to advertise their roadside presence too. As an example, witness the Ace Neon crew installing this beauty at the Sam Byrd course on Montclair Road. (Ace Neon collection.)

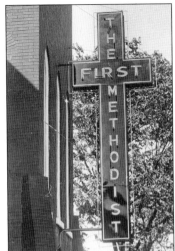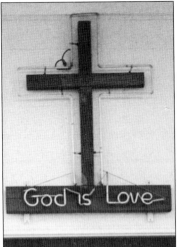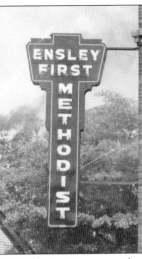

Churches might have been the last place anyone would think to look for classic neon signs, but these photographs illustrate at least three different styles that could be found. The cross (left) and the more generic vertical sign (right) were the most common, but occasionally a church would get even more creative, as with the center photograph of the neon cross and slogan. (Birmingham Rewound collection.)

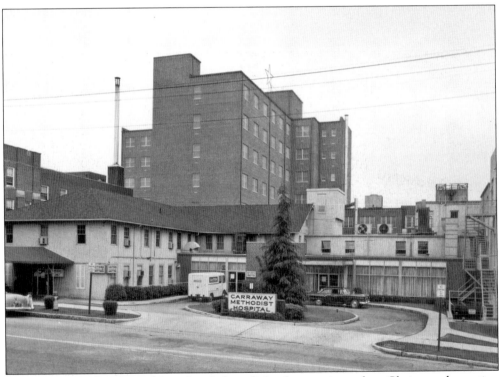

Carraway Methodist Hospital first placed a huge lighted star on its roof as a Christmas decoration in 1958. From 1965 on, the star was left in place year-round as the facility's symbol, and even under its current name of Physicians' Medical Center Carraway, a blue star is still its official logo. (Birmingham Rewound collection.)

Six

IF YOU LIKE BARGAINS

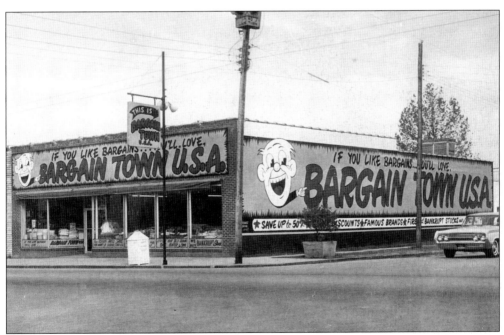

The chain of Bargain Town U.S.A. discount stores was founded in Birmingham in 1957. For the next 25 years, radio and television audiences were treated to the familiar cha-cha-cha jingle—"That's why people from all over town say if you like bargains you'll love Bargain Town . . . U-S-A!" (Rodney Barstein collection.)

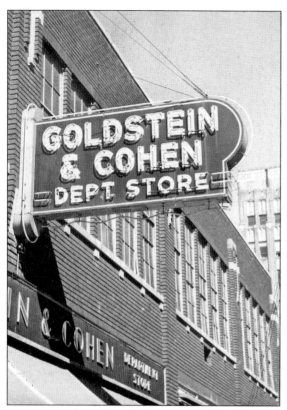

As with the neighborhood movie theaters, Birmingham's suburbs had plenty of stores to rival the huge downtown retailers. Goldstein and Cohen in Ensley was among the most renowned of these. (Ace Neon collection.)

Another upscale clothier was the Vogue in Homewood. In this fading print, not only are the Play Pen toy store and Homewood Theatre marquee visible in the background, but so are some less-than-extravagant Christmas decorations strung across U.S. 31. (Dixie Neon collection.)

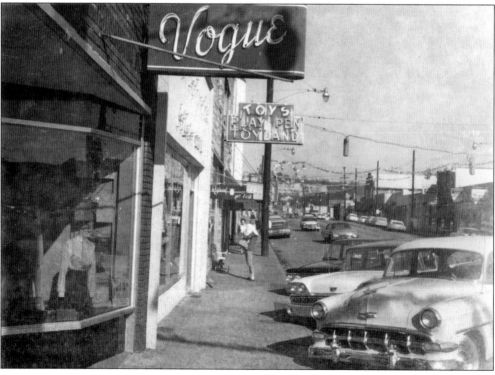

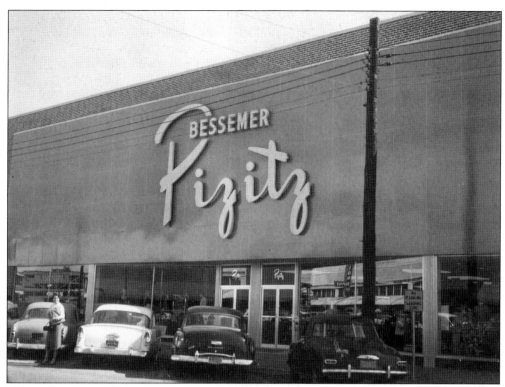

The anchor stores of downtown expanded into the suburbs during the 1950s. Pizitz's branch store in Bessemer was one of the first, with others including Loveman's, Yeilding's, Parisian, and Kessler's following close behind. (Dixie Neon collection.)

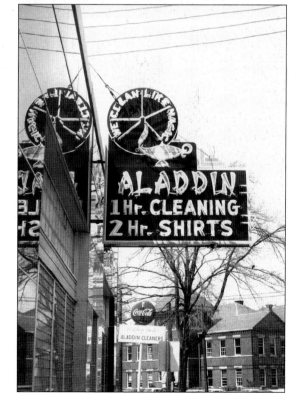

This laundry in Woodlawn had an unusually elaborate sign for a business of its type. We have to wonder whether the employees went to sleep by being inhaled into ancient oil lamps every night. (Ace Neon collection.)

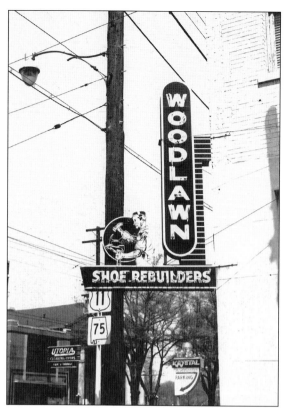

The shoemaker on this sign did not even need the help of any elves to keep his business going. Below the shoe sign, notice the crystal ball and original Middle Eastern lettering of the Krystal hamburger stand on the corner. (Ace Neon collection.)

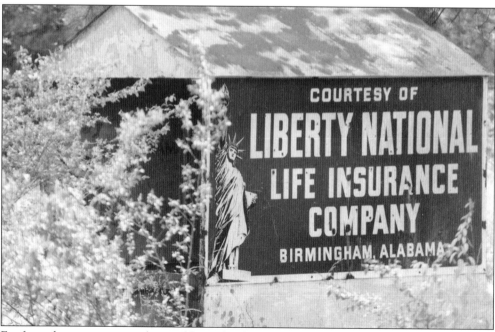

Far from the city streets in the rural hinterlands, Liberty National Insurance endeared itself to parents by providing shelters for their little beneficiaries to await the school bus. (Birmingham Rewound collection.)

Branch banks were common in nearly every suburban neighborhood. This photograph was made just prior to the Exchange Bank exchanging its old name and securing a new one, Exchange Security Bank. It really does not matter what name it had since it later became First Alabama and is today known as Regions. (Dixie Neon collection.)

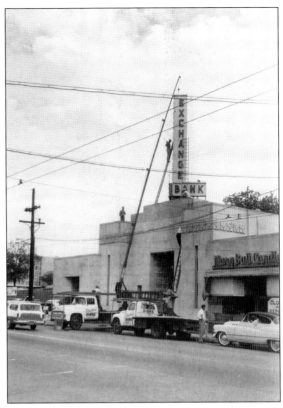

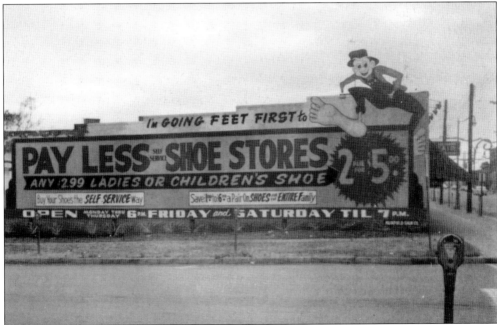

Wow! Get an eyeful of those fantastic feet and titanic toenails on this hillbilly that adorned the side of the Pay Less shoe store in Fairfield. Pay Less was another discount venture from the Barstein family of Bargain Town U.S.A. fame. (Rodney Barstein collection.)

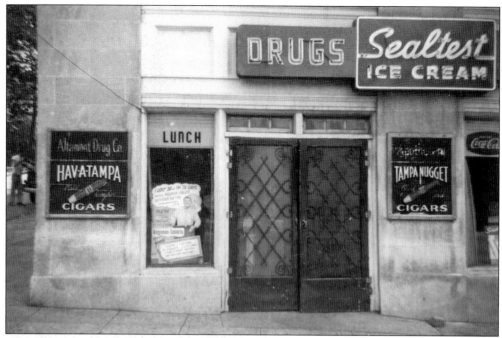

The Altamont Drug Company was a splendid example of both the neon Sealtest ice cream sign and the hand-painted advertising for Tampa cigars. (Skidmore Signs collection.)

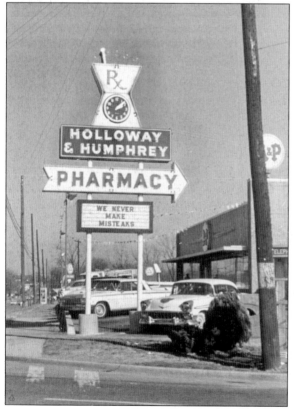

Even though the age of prepared medications rendered the traditional mortar and pestle all but obsolete as pharmacists' tools, drugstores from coast to coast continued using them as an immediately identifiable logo. Holloway and Humphrey, with stores in both East Lake and Adamsville, made the emblem into a huge roadside clock at both locations. (Dixie Neon collection.)

Although Skelton's 5-and-10¢ store was not owned by Red, the name still conjures up images of the sales clerks tripping and falling over the merchandise counters. Maybe they also wished departing customers, "Good night and God bless." (Dixie Neon collection.)

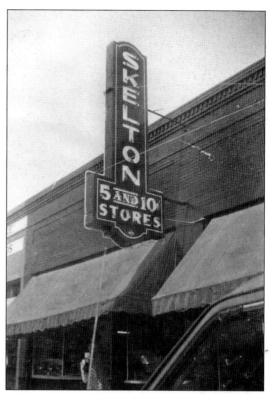

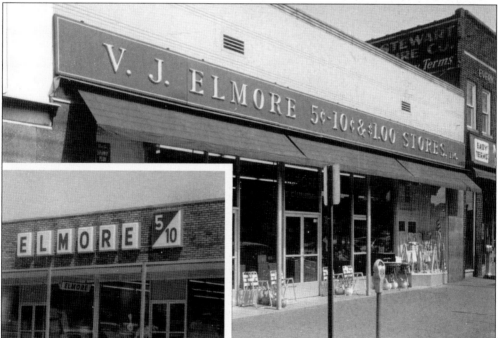

The chain of V. J. Elmore dime stores had locations throughout the northern half of Alabama; its original signage is seen on the North Birmingham store here. The inset photograph shows Elmore's later 1960s sign as installed on the store in Sumiton. (BPL collection.)

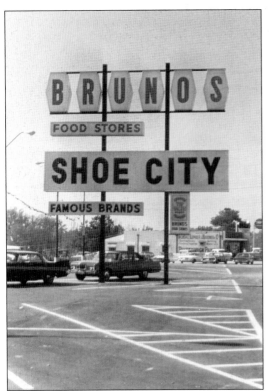

Bruno's was Birmingham's most familiar home-grown chain of supermarkets. Whereas other supermarkets offered Green Stamps or Plaid Stamps, Bruno's went for the gold with the yellow Top Value Stamps. (Dixie Neon collection.)

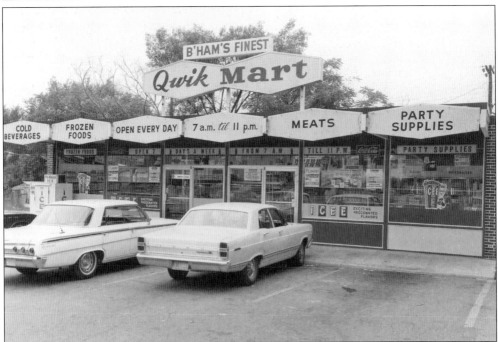

Qwik Mart was one of the first chains of "7-11" stores ever seen in Birmingham. Look closely at this one, located across the street from Rickwood Field, to see the signs promoting a relatively new taste treat, the Icee frozen drink. (Birmingham Rewound collection.)

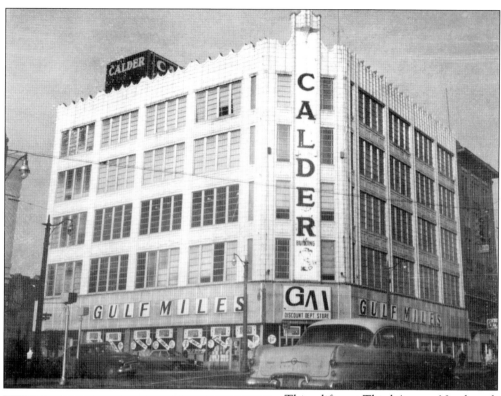

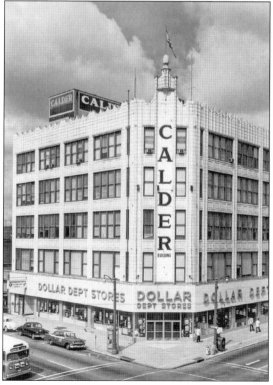

This edifice at Third Avenue North and Eighteenth Street was originally built in 1928 as the Parisian flagship store. After a stint as the temporary quarters of Loveman's from March 1934 to November 1935, it served as the longtime home of Calder Furniture. After Calder moved to a smaller building on Second Avenue, a succession of discount stores rented space on the old structure's first floor. Among the budget buddies in these photographs are the Gulf Miles (pictured above) and Dollar Department Stores (pictured left). (BPL collection.)

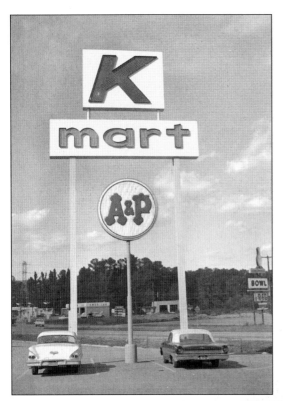

Kmart was the discount outgrowth of the much-older S. S. Kresge chain. This example was on Green Springs Highway; across the street notice the sign for the bowling alley that later became the four-screen movie theater seen on page 94. (Dixie Neon collection.)

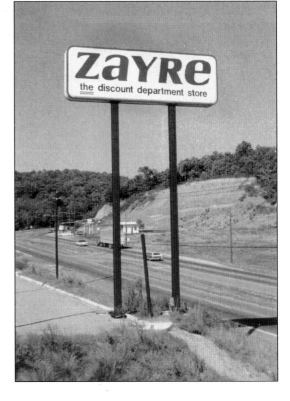

Another well-remembered giant discount store of the 1960s and 1970s was Zayre, the U.S. 78 location of which is seen here. The dirt field in the background would become the site of the Century Plaza shopping mall in 1974. And speaking of malls, that leads into the final section beginning on the next page. (Ace Neon collection.)

Seven

ONE-STOP SHOPPING

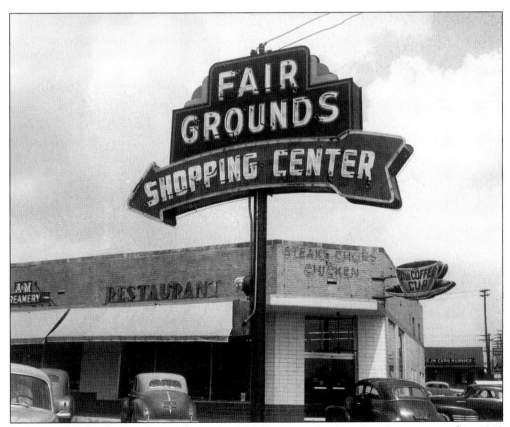

Before malls, there were shopping centers. The Fairgrounds Shopping Center opened in 1948 as one of the first such concentrations of stores and restaurants all in one centralized location. (Alabama Neon collection.)

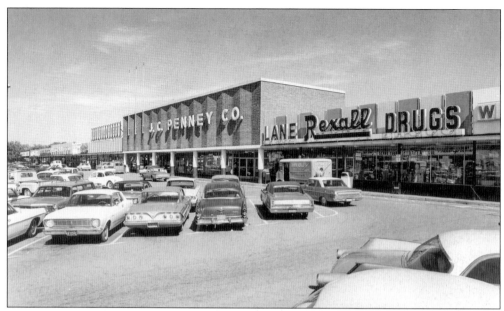

Within a decade, the Fairgrounds Shopping Center had expanded into what is better known as Five Points West Shopping City. As can be seen here, it offered a wide variety of businesses situated along a single sidewalk. (BPL collection.)

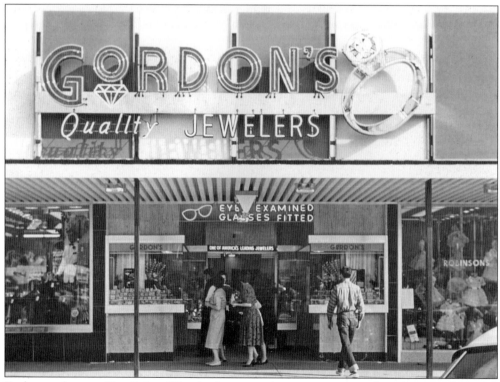

Each storefront at Five Points West had its own distinctive signage, but the neon lettering and diamond ring at Gordon's Jewelers was a jewel in the shopping center's crown. (Dixie Neon collection.)

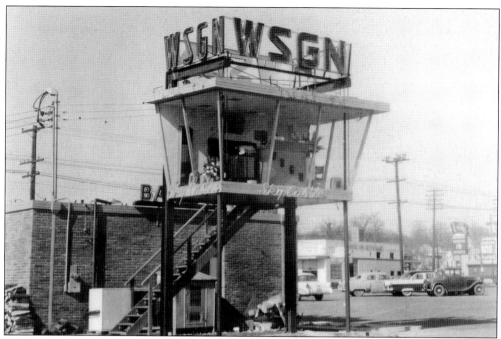

As the popularity of Five Points West grew, WSGN moved its Sky Castle to the back wall of the Hickory Hut restaurant. Teens still flocked to the parking lot to watch the live radio broadcasts. In the background is the sign for the Igloo drive-in, another famous Five Points West hangout. (Dixie Neon collection.)

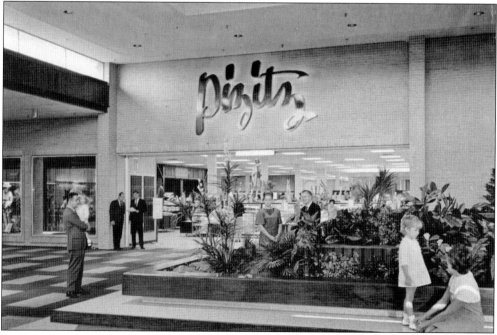

In 1968, heavy hitter Pizitz moved into Five Points West, spurring the construction of a new enclosed mall portion. The models recruited for this publicity photograph might look a bit overdressed to be visiting a mall of today. (Birmingham Rewound collection.)

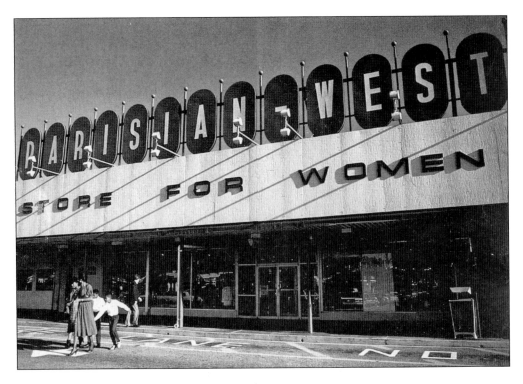

Two other long-established chains that set up shop at Five Points West were Parisian (above) and W. T. Grant (below). The Grant's photograph illustrates a secondary type of sign seen at these strip centers: the small lighted sign suspended from the ceiling that was meant to identify the store for shoppers on the sidewalk who could not see the signage on the front of the building. (Birmingham Rewound collection.)

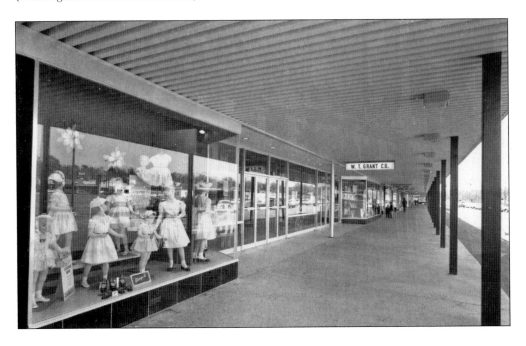

Birmingham's second shopping center was in Roebuck and opened in 1957. Of special note in this shot are the "in" and "out" signs sponsored by Red Diamond coffee, which were common sights in parking lots throughout the area. (Dixie Neon collection.)

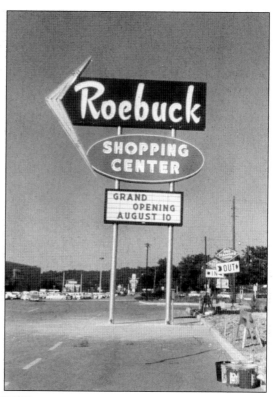

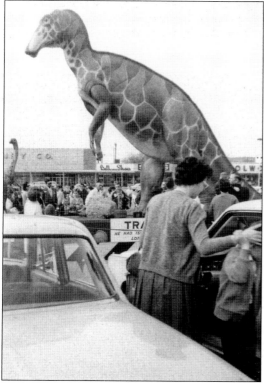

As mentioned earlier, in March 1967, the dinosaurs from Sinclair's New York World's Fair exhibit made tracks into Roebuck Shopping City. The trachodon is towering over J. C. Penney, Woolworth's, and other Roebuck stores in the background. (Birmingham Rewound collection.)

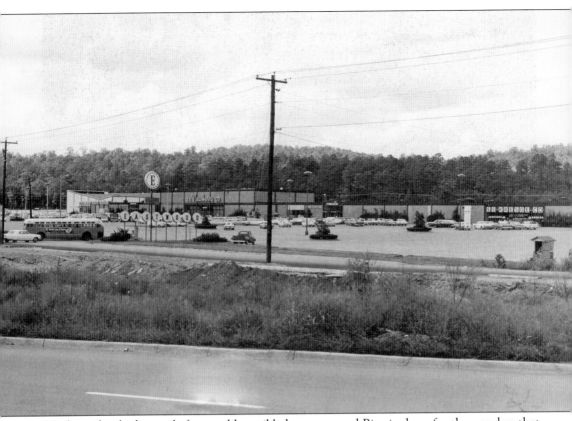

Nothing that had come before could possibly have prepared Birmingham for the wonders that awaited it when Eastwood Mall opened on August 25, 1960. The city had never seen anything like it, as it was the first all-enclosed shopping mall in the South. Eastwood was the brainchild of developer Newman Waters Sr., who also owned several of the downtown movie theaters. Farsighted Waters was able to see that the future of Birmingham retail was going to lie in the suburbs rather than the traditional old city center, and Eastwood Mall proved that he was right. (Birmingham Rewound collection.)

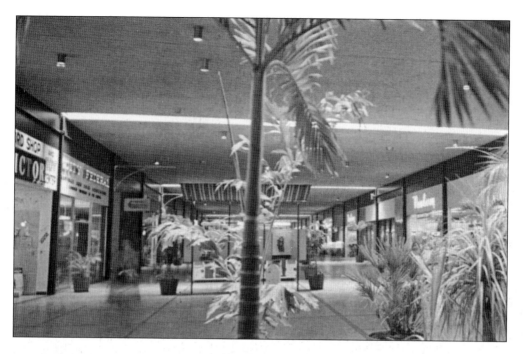

In its publicity, much was made of Eastwood Mall's "air conditioned sidewalks," which provided the experience of strolling between rows of stores without being subjected to the weather extremes of Alabama. In the photograph above, notice that the photographer had to use such a long exposure time to capture the mall's interior that he also ended up with the ghostly image of a transparent lady shopper passing by. (BPL collection.)

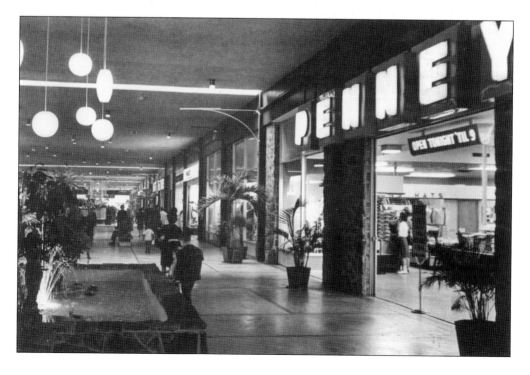

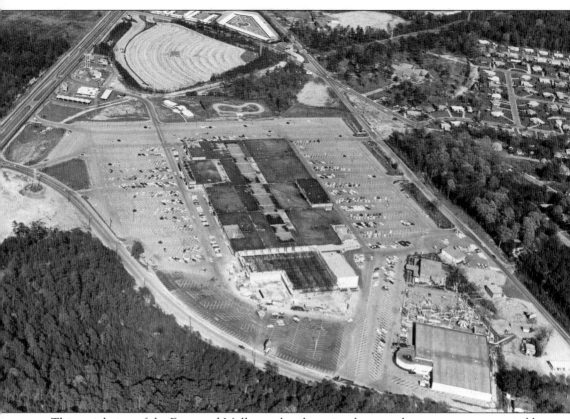

This aerial view of the Eastwood Mall complex shows just how much property was occupied by this new development. At the top left-hand corner is the Starlite Drive-In Theatre, which would soon be replaced by a separate strip shopping center anchored by Kmart. In the lower right-hand corner is the famous Eastwood bowling alley with an adjoining amusement park and miniature golf course. In the center, Eastwood's first major expansion can be seen taking shape with the girders of the new movie theater. (Birmingham Rewound collection.)

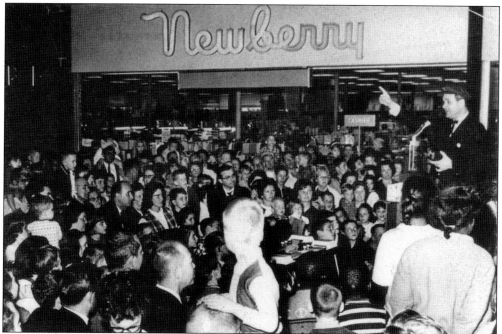

Although the J. J. Newberry store downtown remained popular, the Eastwood Mall branch of the chain became an even more familiar memory to many. Here Channel 13 superstar "Cousin Cliff" Holman packs them in for one of his many personal appearances. (Birmingham Rewound collection.)

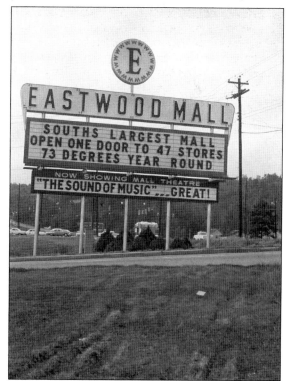

Eastwood Mall's original signage, with each letter enclosed in a circle, can be seen on page 118. This different style of sign was erected on the U.S. 78 side of the property a few years after the opening. (Dixie Neon collection.)

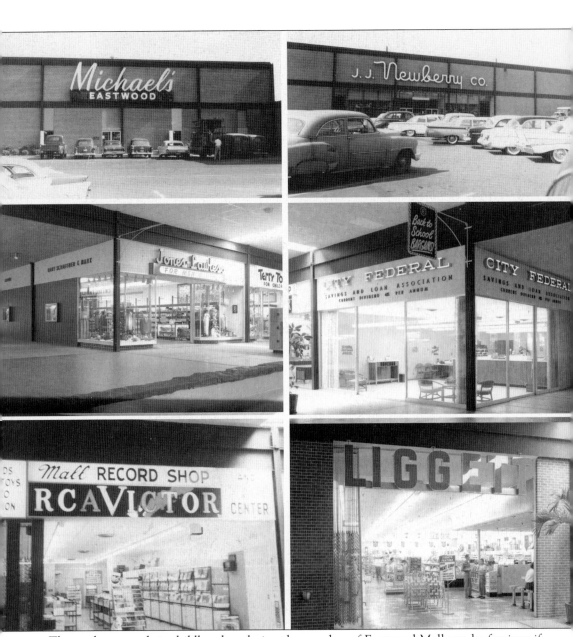

Those who spent their childhood exploring the wonders of Eastwood Mall can be forgiven if they have to reach for a handkerchief or two by this point. In this collage is an assortment of the businesses that worked together to form fond memories for all, from Michael's restaurant to the

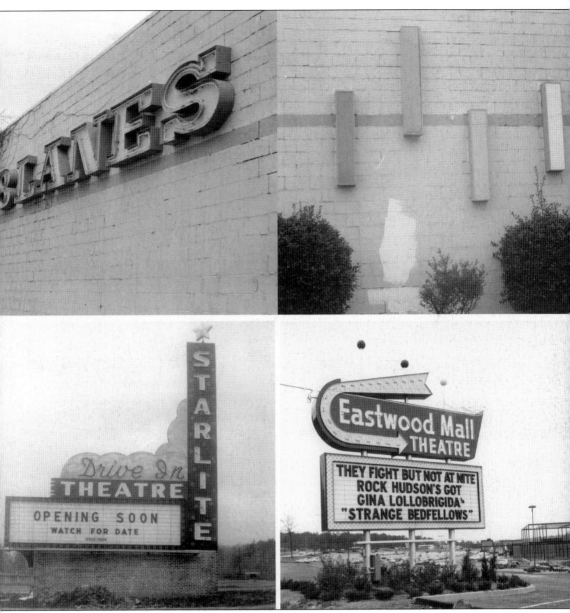

Liggett drugstore, and from the bowling alley to the record store. (Some people did not grow up listening to CDs.) As you can see, City Federal and Jones-Lawless also set up branches along the "air conditioned sidewalks." (Birmingham Rewound collection.)

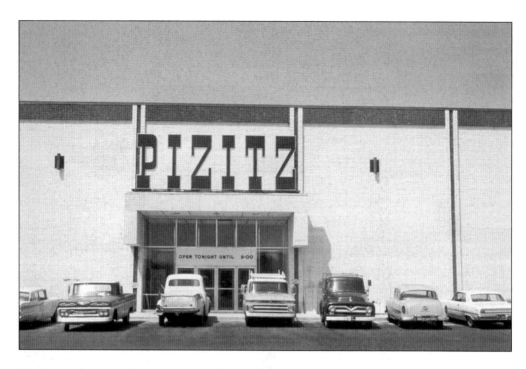

No Birmingham retail center was complete without a Pizitz branch store, and Eastwood Mall was no exception (above). After Pizitz moved across the street to Century Plaza in 1980, the building became Service Merchandise. The photograph below shows its ultimate fate: the entire Eastwood Mall structure was bulldozed in 2006 to make way for a new Wal-Mart development that opened in October 2007. (Birmingham Rewound collection.)

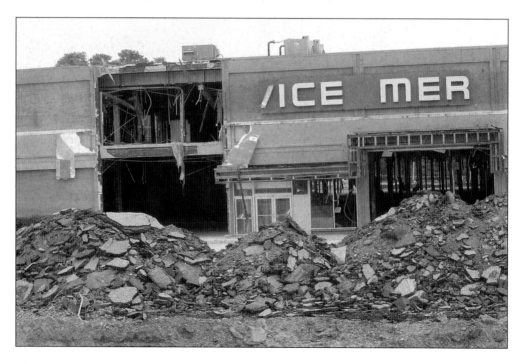

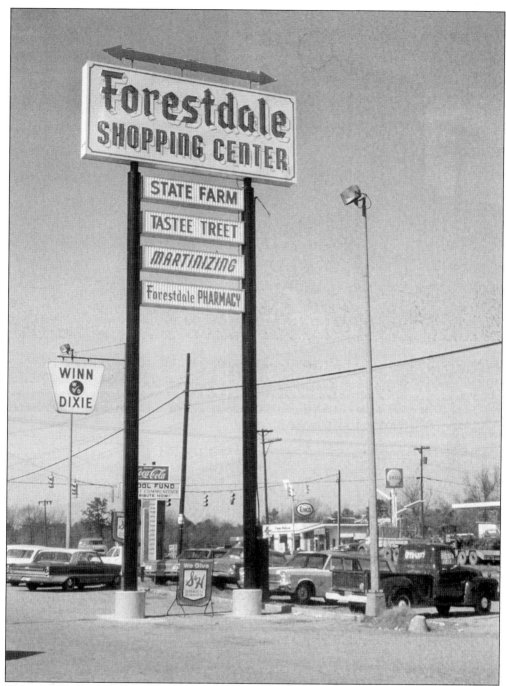

Even after the rise of enclosed malls, a few, small, outdoor shopping centers continued to emerge, such as this one in Forestdale. On the other side of U.S. 78 is the Shell station that was being advertised on the billboard on page 82; amazingly, the Enco station remains in business under that oil company's present name of Exxon. (Dixie Neon collection.)

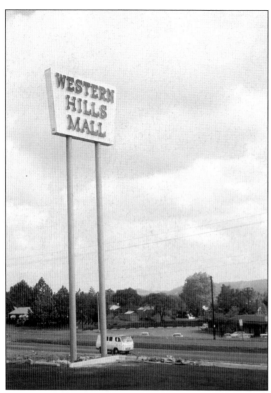

Birmingham got its second enclosed mall with the opening of Western Hills Mall in Midfield in 1969. The original roadside signage reflected the name with lettering that vaguely hinted of cowboys and branding irons. (Dixie Neon collection.)

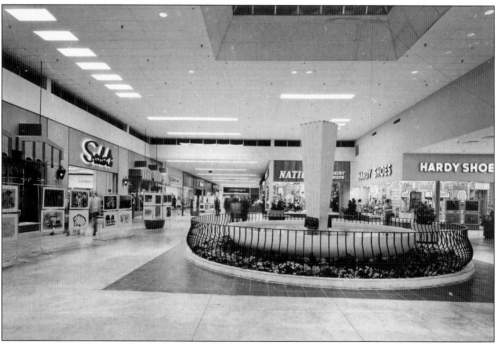

The interior of the newly opened Western Hills Mall was just as impressive as its forefather, Eastwood Mall, but not nearly so much of a novelty by the late 1960s. (Birmingham Rewound collection.)

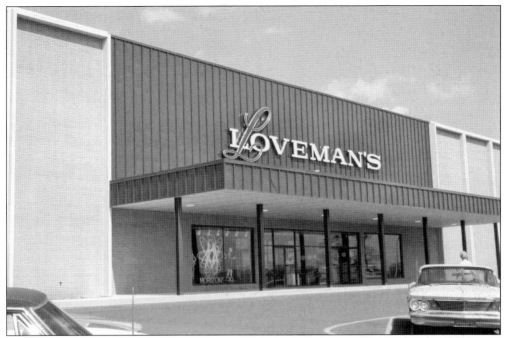

Initially, Loveman's became one of the Western Hills Mall anchor stores instead of Pizitz. However, when the Loveman's chain went out of business in the spring of 1980, all but the downtown store were bought out by Pizitz, so that chain did get its foot in the Western Hills door, although belatedly. (Dixie Neon collection.)

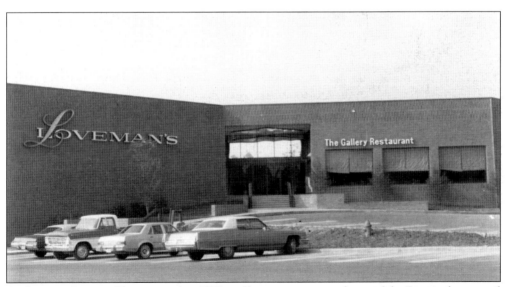

By the time Century Plaza opened in 1974, malls were an accepted part of the Birmingham retail scene. Loveman's opened its final branch store there, although it would have only six years before it too became a Pizitz outlet. When Pizitz itself sold out to Mississippi-based McRae's in 1986, both Birmingham retail kings' names had been erased from the landscape. (Wes Daniel collection.)

ACROSS AMERICA, PEOPLE ARE DISCOVERING SOMETHING WONDERFUL. *THEIR HERITAGE.*

Arcadia Publishing is the leading local history publisher in the United States. With more than 4,000 titles in print and hundreds of new titles released every year, Arcadia has extensive specialized experience chronicling the history of communities and celebrating America's hidden stories, bringing to life the people, places, and events from the past. To discover the history of other communities across the nation, please visit:

www.arcadiapublishing.com

Customized search tools allow you to find regional history books about the town where you grew up, the cities where your friends and family live, the town where your parents met, or even that retirement spot you've been dreaming about.